MILLENNIUM COLLECTION

A TWENTY-FIRST CENTURY CELEBRATION OF FINE ART IN NEW MEXICO

WILLIAM D. LAICHAS KATHRYNE FOWLER NANCY N. STEM

NMMC
SANTA FE

FRONT COVER

BARBARA ZUSMAN
Twenty-One Poems for Andre Lorde
Steel, mixed media on wooden found object, pigments,
coffee and starch on industrial foam rubber
67.5 x 17.5 x 12"
Courtesy Linda Durham Contemporary Art

TED LARSEN
Strong Autumn Color
Pastel
27 x 60"
Courtesy Ventana Fine Art

BACK COVER
Clockwise from top left:

FLORENCE PIERCE
Untitled, Red #237
Resin on mirrored plexiglas
24 x 24"
Courtesy Charlotte Jackson Fine Art

BELLA COOLA FRONTLET
ca. 1870
Courtesy Morningstar Gallery

LAGUNA SANTERO
Santa Rosa de Lima Retablo
Gesso relief and pigment on board
32.75 x 18.75 x 2"
New Mexico, ca. 1780
Courtesy Peyton Wright Gallery

WILLIAM LUMPKINS
Aerial
Acrylic on paper, 1989
45 x 45"
Courtesy Cline Fine Art Gallery

KEN PRICE
Slope
Fired and painted clay, 1999
9.75 x 22 x 16.75"
Courtesy James Kelly Contemporary

FRONTISPIECE

DARREN VIGIL GRAY
Motherland of Basketmakers #4
Acrylic on canvas
54 x 48"
Courtesy Peyton Wright Gallery

THE NEW MEXICO MILLENNIUM COLLECTION

Published by: The New Mexico Millennium Collection, LLC
　　　　　　　Post Office Box 863
　　　　　　　Tesuque, New Mexico 87574
　　　　　　　505.466.0776

Design: Alex Cassidy
Production Editor: Suzanne Deats

Printer: Advanced Litho, Great Falls, Montana

ISBN 0-9679034-0-8
Library of Congress Catalog Card Number: 00-100915

CONTENTS

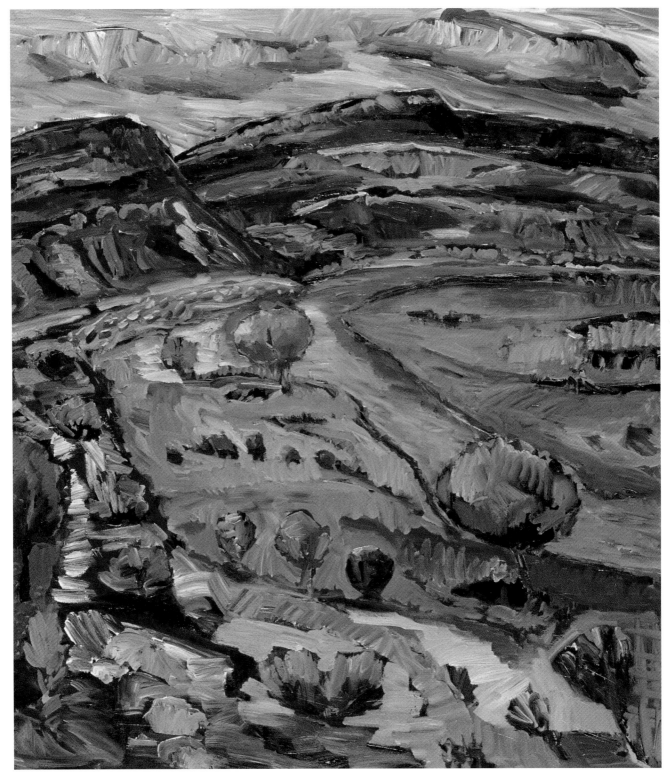

Darren Vigil Gray
Motherland of Basketmakers #4
Acrylic on canvas
54 x 48"
Courtesy Peyton Wright Gallery

FOREWORD

Welcome to the New Mexico Millennium Collection.

As publishers of this new book, we've had but a single goal: to present the astonishing beauty, quality, and variety of works of art created or displayed in New Mexico, works that have made the state a prominent art center.

To accomplish our goal, we've used the widest possible wide-angle lens. The sheer numbers of art, artists, and galleries prohibit anything but a glimpse of the art of New Mexico as we begin the new millennium. Thus, we present an overview of many of the masters of the past and present-day notables, alongside the stars of the future.

From the early Taos artists to today's cutting-edge painters, from Native American weavers and early Spanish *santeros* to internationally celebrated sculptors, and from a multicultural mix of works by Hispanics, Native Americans, and Anglos, to art and relics from the seven continents, New Mexico's diversity attracts serious collectors and art lovers from around the world. The New Mexico Millennium Collection is about much of what has caused and continues to cause that attraction. And, happily, as long as there is the mystery and grandeur of high desert light, New Mexico will produce and nurture fine artists, craftsmen, and the galleries and dealers who promote their work.

We would like to thank all the contributors, especially the many artists, galleries and collectors, for their participation in offering their works and objects for display. Their generosity makes it possible to share such grace and elegance. Much of the New Mexico Millennium Collection contains art and objects that readers can still add to their personal collections. Most of the artists represented in the book are active and producing new art. The many galleries who have contributed to this book represent these and other artists who merit attention and interest, as well as the fine art crafts, relics and antiquities that complete the panorama that is New Mexico art today.

Many thanks also to Jan Adlmann, Ian Alsop, David Clemmer, David Witt, production editor Suzanne Deats and certain anonymous writers, editors, and researchers for their invaluable contributions to the content of the book, and especially for their encouragement in the creative process.

William D. Laichas
Kathryne Fowler
Nancy N. Stem

COMING TO NEW MEXICO

Tally Richards, the legendary Taos art dealer, was once asked to describe how she felt about her home. "For me," she answered, "it's somewhat like the next step before infinity." The question was as vast as the endless horizon which rides forever west from the Sangre de Cristo Mountains. It begged for an enigmatic answer, although the answer remains always mysterious.

Among the first to paint their impressions about the Land of Enchantment were two New York artists, Ernest Blumenschein and Bert Phillips. Like many American artists of their time, both had taken formal training in art while students in Paris. Both were thoroughly bored with that experience when they received the call to adventure from Joseph Sharp who had already visited Taos early in the 1890s. All three were determined to search for an authentic American vision of art. And what they sought was in New Mexico.

Blumenschein and Phillips began their 1898 journey in Colorado, buying a wagon and horses, turning south to head toward Mexico. They never made it. Intending to go to Santa Fe, they instead crossed La Veta Pass in southern Colorado and came first to Taos. The reason for their change in travel plans is unknown. It was almost as if they came by chance – if chance is the word for the forces that seem to be at work in the Southwest. In the small mountain community of Taos, and eventually within the larger cultural and geographic scope of New Mexico, Blumenschein and Phillips found what they sought. To begin, nearly every landscape type in the West could be found in Taos, from desert at the bottom of the Rio Grande Gorge to vast ponderosa and spruce forests and, above those, alpine regions whose tundra was not unlike that of Alaska. Perhaps more important was the human history and the cultures which had integrated with the land to exist as an inseparable part of it.

Much of the imagery for which the twentieth century artists of New Mexico are known, and the better part of the inspiration which draws artists here, or forms those who were born here, rests on the deep base of Native American and Spanish/Latin civilizations. Those who made and who were made by the environment before the Anglo-Americans came, had their own traditions which newcomers could not ignore. The coiled baskets, tightly woven wool blankets, silver bracelets inlaid with turquoise, and jet black pottery from the great artists of the Indian tribes would grace innumerable canvases of European-American painters. The grace, power, and nobility of Indian ceremonials would come to characterize what was truly native in America. The Spanish-speaking descendants of carvers and furniture-makers from Spain had built their own artistic vision of the Southwest. The 19th century *santeros* (saint-makers) created paintings of passion and sensitivity unequaled in other American art of that period. When the immigrant artists saw the great adobe dwellings at Taos Pueblo and the massif of a church named for St. Francis at Ranchos de Taos, they began to understand the light. Light both as a physical phenomenon but also as a guiding spiritual metaphor.

The artists, both those who were born here and those who came from somewhere else, knew in their hearts that such a combination of cultures and history and landscape existed nowhere else. Although it was far from the centers of power, politics and finance, New Mexico nonetheless became an important center for American art in this century. The atmosphere of creativity, however, arose not out of idyllic romanticism, for the sometimes dark history of New Mexico suggests otherwise. The tension which has by turns plagued and inspired New Mexicans since the Spanish *Entrada* in the 16th century, has arisen in part from different rates of change for different aspects of the state, creating our sense of place. Demographic and economic change moves differently over time than changes in the physical character of pristine light, towering mountains, and the Great River coming over the border from the north. In this environment New Mexicans attempt to find balance or at least accommodation with their neighbors, with the cultures already here and those which arrived later, with the snow storms that make pastoral rural highways into wildernesses, and with the droughts that sometimes last much too long. New Mexico is not an unchanging land of *poco tiempo* – that is a mistaken perception of

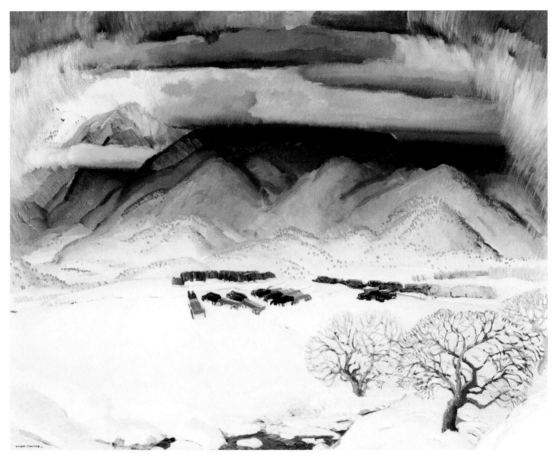

Victor Higgins 1884-1949
Winter Funeral
Oil on canvas, 1932
46 x 60"
Courtesy The Harwood Museum, Taos

outsiders. New Mexico is dynamic in the ever changing and complex relationships of its people and environment. It is this complexity that gives rise to enigmas. It is to explain enigmas that we have artists and poets.

•

The Roswell Museum and Art Center owns one of the premier paintings in New Mexico by one of America's finest artists. Marsden Hartley painted *Landscape, New Mexico* in 1920, a desert scene with lumpy clouds, breast-shaped hills, and spiral arroyos. Even after he left New Mexico, Hartley continued to paint the fantastic landscapes of New Mexico, dark and haunting reminiscences of a place he could not escape. Along with Victor Higgins' painting of Taos Mountain, *Winter Funeral*, at the Harwood Museum, and a few other works, it is difficult to escape the images that these

artists have defined. A winter sunset shining gold light and casting black shadows on Taos Mountain recalls the images of Ernest Blumenschein. The bright, unbearable luminosity of summer sagebrush plains brings to mind Walter Ufer's painted depictions of white light on a stark, dry land, an environment unmuted by moisture or subtlety, and that goes right through your sunglasses.

Do we as art-viewers see Taos Mountain the same way Victor Higgins saw it, thus finding a reason for an affinity for his painting? Or do we interpret the land as we do because of how artists have defined it for us? The poet-architects who built Zuni, Acoma, and Taos Pueblos, the Rio Grande weavers who built solid structure with color and line, the painters Andrew Dasburg, Gustave Baumann, Rebecca James, José Aragon, T. C. Cannon, and the woodcarver Patrociño Barela

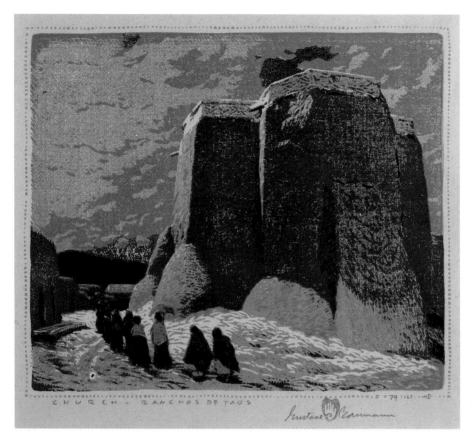

GUSTAVE BAUMANN 1881-1971
Church – Ranchos de Taos
Color wood block print
9.25 x 11"
Courtesy Zaplin-Lampert Gallery

demonstrated new ways of seeing. The collection of enigmas that comprises New Mexico may make sense because of the imagery created by these artists.

Driving west on Highway 64 from Clayton to Raton, there is a long, gentle curve in the road, one of those which seems to have been put in more to break the straightness of the route than for any geographic reason. To the northwest, an arroyo winds toward a single large hill, and beyond, in the distance, two more rocky mounds of indeterminate size stand close together in a very feminine way. This may be the exact spot from where Hartley painted *Landscape, New Mexico*. Then again, it could be a place that no artist has ever depicted. Georgia O'Keeffe has been quoted as saying, "If you ever go to New Mexico, it will itch you for the rest of your life." Of course, artists are prone to exaggeration.

•

Every important social movement is accompanied by the development of supportive structures. New Mexico had only achieved statehood in 1912 and there was little awareness of the Southwest by the rest of the

country. Carlos Vierra, Kenneth Chapman and a few others formed a nascent group of artists in Santa Fe. A few more artists came and went from Taos, but making a living was difficult. In 1915 the artists themselves came up with the solution by creating the Taos Society of Artists. This art-marketing group, which eventually came to represent artists in both Taos and Santa Fe, circulated exhibitions of their work around the country. Los Cinco Pintores, a group of Santa Fe artists, formed a group of their own in 1921 and established the Canyon Road area as a neighborhood of artists. The New Mexico Painters organization followed in 1923, drawing members from both of the earlier groups.

Art institutions developed in the form of museums and foundations, but some individual personalities were so powerful that they might also be thought of as institutions. Dr. Edgar L. Hewett presided over both the School of American Research and the Museum of New Mexico, including opening the beautiful Museum of Fine Arts in 1917. Santa Fe continued as a leader in the arts with the creation of Native Market (1922), Spanish

Market, and the Spanish Colonial Arts Society (1925), the Laboratory of Anthropology (1931), The Studio of the Santa Fe Indian School under Dorothy Dunn (1932), the Museum of International Folk Art (1953), the Institute of American Indian Arts (1962) and many others as well.

In Taos, Phillips and Higgins joined Elizabeth Harwood to create the Harwood Foundation (1923), and the Harwood became the host for the University of New Mexico Summer Field School of Art (1929). The Federal Art Project (1936) of the WPA operated throughout the state and gave artists such as Patrociño Barela a chance to make a real career. Hundreds of prints, paintings, murals, and carvings were created through Federal support.

Notably, those individuals whose sheer presence gave them institutional force in the life of the art colonies were often women writers. Alice Corbin Henderson and Mary Austin held court in Santa Fe for the local art elite and for visiting celebrities from all over the country. Some of their guests went on to see Mabel Dodge Luhan in Taos. During the twenties, Luhan's presence was felt so strongly in Taos that the community was sometimes referred to as "Mabeltown," (but presumably not in the presence of the lady herself). Mabel's books about herself and about Taos, as well as her hosting writers from D.H. Lawrence to Robinson Jeffers, made her a prime publicist for Taos in particular, and New Mexico in general. Long an activist, before moving to Taos she had been instrumental in creating the 1913 modernist art show at the Armory in New York and, after coming to New Mexico, she served as a champion promoting Native American rights. In 1929, Mabel had the luggage of New Mexico visitors Rebecca James and Georgia O'Keeffe taken from the train station at Lamy to her home to Taos, more or less forcing the visiting women to follow her in order to retrieve it.

O'Keeffe, of course, became the biggest name on the New Mexico art scene. Some of her contemporaries such as Hartley or Dasburg had greater mastery of the paintbrush, but no other artist so captured the public's imagination. Her clear, straightforward imagery beckoned the viewer into her world, making bold statements about the emotional impact of the American West. Paintings such as the ones of dark crosses standing

in stark contrast to the distant mountains are highly abstracted, yet also work as a narrative of the relationship between the people and the land.

National recognition of the art of New Mexico waxed and waned over the decades until the 1960s when the accomplishment of New Mexico's artists found a more permanent place among both collectors and art historians. The first major exhibition of Taos and Santa Fe artists took place at the University of New Mexico in Albuquerque in 1964. Also in that year, the acclaimed writer Frank Waters brought out a memoir on the late Russian artist and long-time Taos resident, Leon Gaspard. Three years later, art dealer Fred Maxwell opened an important retrospective of Gaspard's work in San Francisco. In Denver, art and book dealer Fred Rosenstock began promoting the Taos Society of Artists. Several Santa Fe galleries expanded or were newly formed to renew the reputations of the painters from Santa Fe and Taos and from elsewhere in the state. Pottery, jewelry, textiles, and furniture, previously sold as crafts, increasingly were seen as a part of the fine arts market. A new generation of American art collectors was introduced to the historic New Mexico painters and many of them took an interest in contemporary New Mexico artists as well.

Residents and visitors often comment on the unexplainable air of creativity that permeates New Mexico and gives rise both to art and to conflict. Creativity flourishes best in a dynamic atmosphere. New Mexico is a place where a sense of discomfort, a long history, a varied landscape of unlimited beauty, and a people who honor both change and tradition, have made art an essential part of their lives.

*The founding members of the Taos Society of Artists were Oscar Berninghaus, Ernest Blumenschein, Irving Couse, Herbert Dunton, Bert Phillips, and Joseph Sharp. Los Cinco Pintores included Jozef Bakos, Fremont Ellis, Walter Mruk, Willard Nash, and Will Shuster. The New Mexico Painters were initially composed of Frank Applegate, Jozef Bakos, Gustave Baumann, Ernest Blumenschein, William Henderson, Victor Higgins, B.J.O. Nordfeldt, and Walter Ufer.

David L. Witt
Curator, The Harwood Museum, Taos. Co-author of Spirit Ascendant, the Art and Life of Patrociño Barela, *author of* Taos Moderns: Art of the New, *and other works on art history.*

CONTEMPORARY ART

By the time that Georgia O'Keeffe made her initial foray to Northern New Mexico in 1929, the trail to the Land of Enchantment was already well-worn by decades of intrepid artists. From the arrival of the founders of the Taos Society of Artists around the turn of the last century to the extraordinarily prolific arts community of the current day, New Mexico's history as a mecca for the arts has become a well documented phenomenon. Were they to find themselves in downtown Santa Fe today, members of seminal groups such as the Taos Society and Los Cinco Pintores would doubtlessly be astonished by the galleries lining those once quiet streets. Yet, as much as things have changed, the allure that so mesmerized the region's early artists remains largely intact.

The land and the light. Newcomers and natives alike have long rhapsodized over the unique qualities of these most precious of New Mexico's natural resources. The cliché may be as old as New Mexico itself, but there is something ineffable about the light and the way in which it falls upon the terrain. The ancient Anasazi undoubtedly felt it, as did the Pueblo peoples and the Navajo, and it continues to work its magic to this day. The land and the culture of its people attracted the artists, and the artists attracted more artists. Tourists, patrons, collectors, museums, galleries, institutions of higher learning, government agencies, non-profit foundations, and arts publications have since followed. The cycle has evolved into a complex dynamic that has achieved a level of sophistication and professionalism that has exceeded all expectations if, in fact, there were any such expectations at all.

If only on the basis of commerce alone, the evolution of the contemporary art scene in New Mexico must surely qualify as one of the more notable success stories of its kind. In recent years, popular wisdom (the exact numbers being somewhat more elusive) has placed Santa Fe second or third in the nation in terms of art-generated revenues, behind New York and, variously, Los Angeles or Chicago. By way of context, consider that New Mexico ranks as the fifth largest state in the union (121,511 square miles) and only has a population of approximately 1.5 million people. In the process of mounting a recent survey of contemporary art in New Mexico, the Museum of Fine Arts in Santa Fe sent out 10,000 requests for submissions – a number which likely represents only a portion of the artists currently resident in the state.

Before proceeding, it would do well to consider the exact nature of this beast known as "contemporary art." It is a term that enjoys widespread usage, but even the most urbane and knowledgeable art connoisseur would be hard-pressed to describe it with any specificity. Contrary to popular belief, the designation of art as "contemporary" indicates no particular style, subject matter, or medium. Like the gryphon or other mythical hybrid creature of the imagination, the notion of the existence of "contemporary art" as a tangible and clearly definable entity is a fiction. The only reasonably accurate definition of contemporary art is the art of the current day – nothing more, nothing less.

And what of the current day? Since the 1960s and the alleged conclusion of the modernist enterprise, we have been wanderers in an enigmatic and unsettled time known as the postmodern era – a period in which no particular aesthetic movement or style has held a position of primacy in the art world. Everything of metaphysical and material culture – past, present, and future – is now grist for the artist's mill, and all of humankind's techno-logical palette is available to realize the artist's vision. The once unambiguous categories that distinguished painters, sculptors, photographers, and even performance artists have become increasingly vague and malleable over the last thirty-plus years, to the degree that such distinctions are now considered by some to be archaic and limiting. If it all sounds confusing, intimidating and

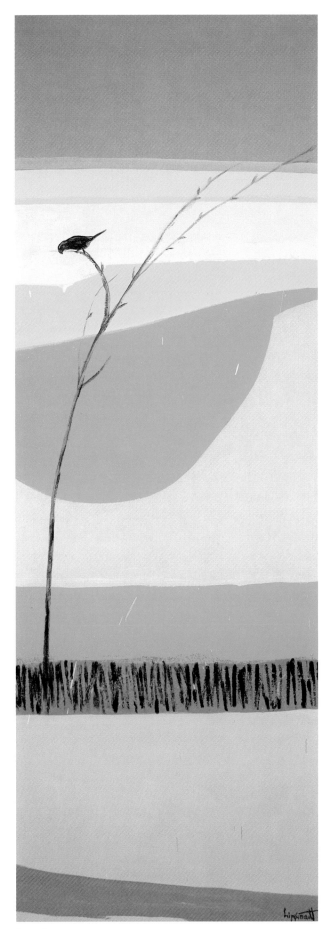

JANET LIPPINCOTT
Willow Branch
Acrylic on canvas
84 x 30"
Courtesy Karan Ruhlen Gallery

JANET LIPPINCOTT
Untitled 1981
Acrylic on canvas
84 x 30"
Courtesy Karan Ruhlen Gallery

WILLIAM LUMPKINS
Aerial
Acrylic on paper, 1989
45 x 45"
Courtesy Cline Fine Art Gallery

rather portentous relative to the quaint and traditional cultural offerings of the Land of Enchantment, guess again: the arts in New Mexico have grown up.

"Grown up," in this case, means engaging in the international dialogue of ideas, materials, and strategies between artists and institutions in New York, in Berlin, in Beijing, in Capetown, in Buenos Aires. Isolation, whether cultural or geographical, is a luxury that New Mexico can no longer afford. If there is no coherent manner in which to summarize or pigeonhole contemporary art in New Mexico, it is because it has become as diverse and complex as contemporary art in the world at large.

The demise, or at least the extensive diversification, of a once stylistically cohesive regional art scene has been vehemently denounced and lamented by some Santa Fe locals in recent years. Despite such protestations, in an era of unprecedented globalization when places the world over seem to be becoming more and more alike, New Mexico has managed to retain its unique character even as it makes its bid for serious consideration as an international arts center. The groundwork for these developments was, in fact, laid by the acclaimed Santa Fe Opera and the Santa Fe Chamber Music Festival

which have been attracting international audiences to the region for decades. Northern New Mexico's place in the popular imagination has long been a tantalizing combination of fact and fantasy. Whether the crafting and marketing of this picturesque, romantic image began with the Taos Society and the promotion of tourism by the railroads, or the popularizing of "Santa Fe Style" by fashion designers and interior decorators in the 1970s and '80s, the essentials remain as cohesive as ever: the land and the light.

Globalization and its effects have become significant areas of investigation for contemporary artists, as evidenced by the three international biennial exhibitions mounted since 1995 by SITE Santa Fe. The 1999 biennial, titled "Looking for a Place," was assembled by the Barcelona-based curator Rosa Martinez, and specifically addressed issues of identity and place in the modern world. Founded in 1994, SITE Santa Fe is a non-profit venue that represents New Mexico's most significant claim for a serious presence in the contemporary art world. Based around the concept of the German Kunsthalle, SITE both hosts traveling exhibitions and mounts shows of its own while maintaining no permanent collection. In addition to its biennial shows, SITE has undertaken an ambitious schedule of year-round programming that features artists from near and far. A more locally-based program of progressive exhibitions is presented by Plan B – an organization which evolved from the Center for Contemporary Art which provided a similar function from the early 1980s through the mid-'90s. The Lannan Foundation, which relocated its base of operations from Los Angeles to Santa Fe in 1998, has recently initiated a stimulating Artist in Residence program, in addition to its excellent literary series. The Lannan presents exhibitions at its Read Street facility, the former home of one of the city's premiere contemporary art galleries, Laura Carpenter Fine Art, which closed in late 1995.

The arts infrastructure of Santa Fe was significantly enhanced in the latter half of the 1990s by the additions of the Georgia O'Keeffe Museum and a spectacular new arts complex (designed by the Mexican architect Ricardo Legoretta) at the College of Santa Fe. These two institutions, along with SITE Santa Fe, owe their existence in

large degree to the patronage of philanthropists John and Anne Marion, who, along with their Burnett Foundation, have transformed the local arts scene. The O'Keeffe Museum is the first museum in the United States devoted specifically to the work of a woman artist of international stature. During the first five and one-half months of its existence, from July 17th through December 31st, 1997, an incredible 200,000 visitors crossed the threshold of the O'Keeffe Museum (far in excess of the initial projection of 150,000 visitors annually).

The College of Santa Fe's visual arts complex provides the city with an educational facility that is at last commensurate with its burgeoning status as an arts capitol. Not to be overlooked is the Santa Fe Community College which is developing an ambitious $9.5 million arts center of its own. The University of New Mexico in Albuquerque remains, however, the powerhouse educational institution in the state. UNM's celebrated painting, sculpture, photography, and art history programs attract talented students and faculty from across the country, and its roster of notable alumni grows more impressive with each passing year.

Another quality that distinguishes New Mexico is that a number of some of the world's most important contemporary artists are counted among its art community. A gauge of the stature of some of these individuals was provided not long ago by a cover story in the respected international magazine ArtNews, which asked, and answered, the provocative question "Who Are the Ten Best Living Artists?" Of those ten, seven live in America (although only four are actually Americans by birth), and two of those seven are full-time residents of Northern New Mexico. The two are the multi-media conceptualist Bruce Nauman and the pioneering minimalist painter Agnes Martin. Neither artist has direct representation with any local commercial gallery, although in 1998 Martin donated a beautiful suite of seven paintings to the Harwood Museum in Taos. (Permanently installed in a meditative chapel-like space created specially for the paintings, the Harwood provides the best experience of Martin's work currently available to the public.) Both Nauman and Martin maintain decidedly low profiles, but much like the late Georgia O'Keeffe, the mere fact of their presence exerts a subtle yet powerful influence.

A number of other artists with towering reputations live in the area, among them the "new image" painter Susan Rothenberg (Nauman's wife), the Italian neo-expressionist Francesco Clemente, the minimalist sculptor/painter Richard Tuttle, the trailblazing feminist artists Lynda Benglis and Judy Chicago, the ceramicist Ken Price, the acclaimed (and controversial) photographer Joel-Peter Witkin, and the wonderfully uncategorizable Larry Bell. In addition, the highly respected art theorists and critics Lucy Lippard and Harmony Hammond, the venerable photographer and scholar Van Deren Coke, and the preeminent photohistorian Eugenia Parry make their homes locally. These individuals constitute a distinguished non-group, in no way representing a "school" or stylistic movement in the manner of earlier generations of New Mexico artists and intellectuals. All of these artists and scholars are New Mexico transplants, and disparate lot though they may be, their collective presence in the Land of Enchantment is by no means a matter of happenstance.

A broad survey of the painters currently living and working in New Mexico today would undoubtedly reveal practitioners of virtually every conceivable category of visual expression, from southwestern genre realist landscape to monochromatic minimalism and every variant in between. Some of these artists have made their homes in New Mexico because New Mexico provides both their inspiration and their subject matter. Others have come to escape the urban art centers of the East and West Coasts, and draw inspiration from their high desert surroundings in a more intangible fashion. Whatever the individual motivation, New Mexico's standing as a destination of choice for artists is now entering its third century.

As in the past, many artists continue to devote themselves to the daunting task of capturing the New Mexico landscape on canvas. A brief (and necessarily incomplete) overview reveals a stylistic diversity of great breadth. The Santa Fe painter John Fincher paints landscapes that, while informed by an awareness of the New Mexico tradition, are by no means limited by it. The same can be said of the Jicarilla/Kiowa artist Darren Vigil Gray, whose vibrant canvases of the Abiquiu River are frequently evocative of the Fauves, the Early American

TED LARSEN
Strong Autumn Color
Pastel
27 x 60"
Courtesy Ventana Fine Art

Modernists, and the German Expressionists whose work he studied in school. The prodigiously talented Mark Spencer, who has characterized himself as a "neo-classical surrealist," often incorporates landscape into his psycho-logically-charged paintings, but does not feel compelled to restrict himself to rendering the mesas and mountains of Northern New Mexico. Daniel Kosharek, a newly emergent talent on the Santa Fe scene, paints blissful high desert vistas with the same dynamic palette and reductive geometry as his Balinese scenes, producing further variations on the regional idiom that are fresh and new. Mary Neumuth's approach to the landscape is truly unique: focusing on a closely observed patch of earth or water practically at her feet, she creates her images by removing layers of paint from the canvas with rags and solvents, resulting in smooth, almost photographic, surface.

Contemporary realism maintains a strong presence in Santa Fe, with a number of galleries in town devoting themselves specifically to the idiom. Prominent realist painters who have lived and exhibited locally for many years include Michael Bergt, Woody Gwynn, Carol Mothner, Bill Shepherd, Daniel Morper, and the extra-ordinary realist/surrealist Brian O'Connor.

Realist landscape painting in New Mexico may be the mostly deeply entrenched of the traditional forms, but other genres also boast an impressive lineage. A direct connection between the New York avant garde and New Mexico was forged in 1918, when the wealthy socialite Mabel Dodge Luhan established her salon in Taos. Luhan hosted many of the progressive artists associated with the photographer and gallery force (and husband of Georgia O'Keeffe) Alfred Stieglitz who accepted her invitation to make the long journey west. The region's historic association with the great innovators of the early American avant garde can be seen as a precedent for the work of vanguard artists of the present day. In a few instances, direct links between modern abstraction, past and present, can still be traced through individual artists, such as the great Florence Pierce. A member of the Taos-based Transcendentalist group of painters of the 1930s and '40s, Pierce's work can be seen in Santa Fe alongside that of young minimalist artists. The elegant abstractions of William Lumpkins (also a member of the Transcendentalist group) can be found on Canyon Road next to the paintings of younger artists inspired by clas-sic 20th century American modernism.

Among the area's younger generation of talented

abstractionists are painters such as Terri Roland, Michelle Cook, Trevor Lucero, Charles Thomas O'Neil, Dirk DeBruycker, and Michael Lujan. Sam Scott, a respected painter in the abstract expressionist tradition, has been working in Santa Fe since the late 1960s, and in 1997 was honored with a retrospective exhibition at the Museum of Fine Arts. The gifted Navajo painter, Emmi Whitehorse, whose work combines Native American symbology with a calligraphic sensibility reminiscent of Cy Twombly, shows alongside Scott in Santa Fe. Paul Sarkisian, who, in the 1970s, painted in a photo-realist style, recently unveiled a series of monumental abstractions that attracted much attention at a 1999 survey of non-objective painting at SITE Santa Fe. James Havard, whose restless spirit of investigation is one of his greatest assets, lives in Santa Fe and shows his exuberantly expressionistic work on Canyon Road.

Native American artists have achieved a prominent place in New Mexico's gallery and museum scene, and their work is often some of the most compelling to be found locally. Darren Vigil Gray and Emmi Whitehorse have already been mentioned, and Dan Namingha, Jaune Quick-to-See Smith, Charlene Teters, and Fritz Scholder are among the most esteemed of Native American painters working today. Up-and-coming young talents such as Tony Abeyta and Gregory Lomayesva are attracting serious attention from collectors, and Taos-based R.C. Gorman remains one of the best-known artists ever to call New Mexico home.

Discrete categories such as abstraction, expressionism, realism, and minimalism are not always adequate to describe the work of many contemporary artists. Orthodoxies of style and content that began to unravel in the latter half of the 20th century will likely face even greater challenges in the 21st. George Fischer, a resident of Ranchos de Taos, received his training in a rigorous academic tradition in Chicago. In recent years, Fischer's expansive paintings have begun to evidence an increasing interest in abstraction, resulting in a uniquely individual style that incorporates both painterly color fields and passages of startling high-realist clarity. Tom Berg, who for over 20 years has made images of chairs his primary subject matter, paints in a soft-focus realist style but with an iconic/ironic sensibility that resolutely defies categoriza-

tion. The intimately romantic/melancholic atmosphere that pervades the landscapes and still lifes of Carol Anthony is equally difficult to classify. Exactly how might one describe the work of the quirky Delmas Howe? Realist Rodeo Homoerotic? Elmer Schooley's vast and densely worked paintings combine an "all-over" compositional sense with a wealth of dizzyingly minute details: might Op-Abstract Landscape suffice to describe his idiosyncratic idiom? Patrick McFarlin, whose energetic portraits of players in Santa Fe's art scene were displayed en masse at SITE Santa Fe in 1997, is yet another artist for whom no single stylistic niche is sufficient. Inadequate term though it may be, it is easy enough to see how "contemporary art" may, in fact, be the only designation broad enough to encompass the art of New Mexico.

Further evidence of connections between New Mexico's past and present can be traced through the Santa Fe galleries, most notably the Gerald Peters Gallery and Nedra Matteucci Galleries. Having built formidable reputations by handling masterpieces of the Taos Society (and, in the case of Gerald Peters, Georgia O'Keeffe), these high profile and highly successful institutions expanded their operations in the 1980s to include contemporary work by local artists. Perhaps the most conspicuous statement of confidence in the future of Santa Fe's art scene has been provided by Peters, whose new 32,000-square-foot gallery near the foot of Canyon Road is dominated by an expansive space devoted to contemporary exhibitions.

Volumes of documentation and analysis have already been written on the arts of New Mexico, and many volumes more are certainly to come. If, as has been suggested, contemporary art can only be defined as the art of the current day, its history will never be written in its entirety. Like any dynamic, living entity it will continue to change and grow. As we embark upon a new century and a new millennium, the possibilities seem as boundless as the high desert plains and mountains of New Mexico itself.

David Clemmer

David Clemmer is a writer and musician living in Santa Fe. His writings have appeared in publications such as THE Magazine, Flash Art, Wired, Art Nexus, *and* Camera Arts. *He is a native of New Orleans and is co-author of* John Clemmer: Exploring the Medium, 1940-1999, *a retrospective catalogue of his father's work.*

CONTEMPORARY SCULPTURE

TACTILE DIMENSIONS

The roots of contemporary sculpture in New Mexico do not tap into the wellsprings that nurtured so much of early painting here. Nonetheless, the artistic atmosphere created by those early artist-settlers and colorful denizens of Taos and Santa Fe most certainly proved as attractive to early sculptors as did New Mexico's inimitably sculptured landscape and indigenous architecture, and our legendary light.

"Contemporary sculpture" refers to any sculpture in any medium, style or manner, created here in the past 30 years. As is the case with our contemporary painting in recent decades, there is no common denominator of sculptural expression or style here, nor, in truth, any sense of regionalism – unless, of course, we were to call our Indian and Hispanic art "regional."

All world art, in the post-modern 20th century, has been characterized by a swift succession of "ism's" and splinter-"ism's," and by a radical rethinking of the very nature of art. This was spurred on by the stunningly expressive possibilities of our late modern technology. Add to this a new compulsion to ransack the art of the past by many young "appropriationist" artists, and an increased melding of art-forms and media. All these phenomena occur in contemporary sculpture in New Mexico.

Before the Anglo artists appeared on our horizon, before the Spanish conquistadors brought their own Iberian artistic heritage overland from Mexico, there was a full-blown Native American tradition in New Mexico that had been refined over centuries. That tradition continues in all its manifestations, such as sand-painting, weaving, pottery-making, and a wealth of other elegant crafts, and is still the cornerstone of Native American visual art.

New Mexican Indian sculptors today, either overtly or subconsciously, bank upon this time-honored foundation and this finely-tuned sensibility. The Native American sculptor, Bob Haozous, for example, most

ALLAN HOUSER
Quiet
Bronze Ed. of 15
25 x 10 x 9"
Courtesy Dewey Galleries, Ltd.

certainly inherited his talents from his celebrated father, Allan Houser, and melded that inheritance with materials (such as acetylene-cut steel) and forms which go back to the beginnings of modern sculpture and the young Picasso. (Although Allan Houser's sculptures depicted traditional Indian subjects, they, too, suggest that he also found impetus toward abstraction from early moderns like Brancusi.) Fine work in the traditional Native American vocabulary is still being created while other artists transform that vocabulary through dipping into the constant flood of new ideas and materials in modern art today.

Hispanic traditional materials, such as polychromed wood-carving (*bultos* and *santos*), ceramics, and metal-smithing, continue to inspire Hispanic sculptors today, either in reverently preserved, backward-glancing styles or in wholly contemporary idioms. For example, today in ceramic sculpture nationally, there is only a handful of original artists. One of these is, most assuredly, New Mexico's Eddie Dominquez, whose carefully crafted cabinets full of crockery turn out to be surreal statements, "demonic dinnerware that's a long, long way from Mom's Limoges."

Luis Jimenez is also nationally known for his powerful sculpture. Often very trenchant images of the social injustices undermining our glorious "tri-cultural heritage," Jimenez's work is still invested with the agony and ecstasy that characterize traditional Iberian sculpture, in the tradition of those thorny, bleeding crucifixions, those dolorous madonnas. At the same time, Jimenez updates those passions and presents them in industrial materials, like plastics and fiberglass.

The tradition of vividly-painted wooden sculpture, such as *bultos* and *santos* figures, is carried admirably forward by Luis Tapia. In one exhibition, Tapia may present the contemporary audience with the most conventional Hispano-Catholic image – a flaming heart – alongside a lively tableau of "low riders" and their girlfriends at the *cantina*, or a portrait of Mary and Joseph, she in mini-skirt and halter, he in a tank top. Aside from the exquisite craftsmanship, it is Tapia's piquant counterpoint of reverence and irreverence that sets his work apart.

The monumental granite sculptures of Jesus Bautista Moroles have likewise received great recognition nationally, to the extent that he is represented in many corporate, private and museum collections. It is phenomenal how Moroles extracts from the unforgiving material of granite such elegant effects of transparency and movement. This Hispanic artist is heir to the tradition of the massive, totemic stone sculpture of the Maya and the Aztecs, yet it is also clear he has absorbed the lessons of modernist abstraction – especially of Noguchi – and it is this which gives his work such authority beyond our region.

Local Indian and Hispanic heritages, often intertwined to mutual advantage, lend a hint of true "regional" flavor to sculpture in New Mexico, though "regional" in this sense by no means infers "provincial." There are, of course, a number of Anglo artists whose work is influenced by the local, native milieu.

Sculpture in New Mexico in the latter years of the 20th century has received a prodigious boost from a handful of individuals, institutions, and businesses which must be given their due. The College of Santa Fe, among our academic institutions, has done the most for sculpture through its huge annual surveys entitled "The Sculpture Project," directed by sculptor/professor Rick Fisher. Many sculptors in every style, medium and scale, have had public exposure, with works scattered across the College campus. Through these ambitious annual events, as many as sixty sculptors may be represented. Informative lectures and programs flesh out the program, while tens of thousands of visitors have an opportunity to assess the state of this art form in New Mexico.

The Albuquerque Museum, as an arm of the City of Albuquerque, has stimulated the public awareness of statewide sculpture through frequent acquisition of large-scale works, ranging from representational to vigorously abstract, which are attractively installed across the Museum's grounds. Still other monumental city commission sculptures punctuate the Albuquerque cityscape. Very noteworthy, and not without the sort of community controversy which often accompanies any meaningful public commission these days, is the Luis Jimenez' large Southwest *Pietá*, a poignant spin upon the prototypical *Pietá* of Michelangelo, installed in the Martineztown section of Albuquerque.

The fabrication of sculpture itself has, in recent years, been greatly advanced by two nationally known Santa Fe companies. In the 1970s, the Shidoni Foundry, in the Santa Fe suburb of Tesuque, was founded by Tommy Hicks. Sculptors from all over the country have turned to Shidoni because of their absolute mastery in the preparation of casts and the perilous pouring of bronze. Large open fields surround their facilities, with two galleries dedicated to traditional and contemporary work, respectively. Shidoni's grounds are an open-air museum of sculpture in the widest possible

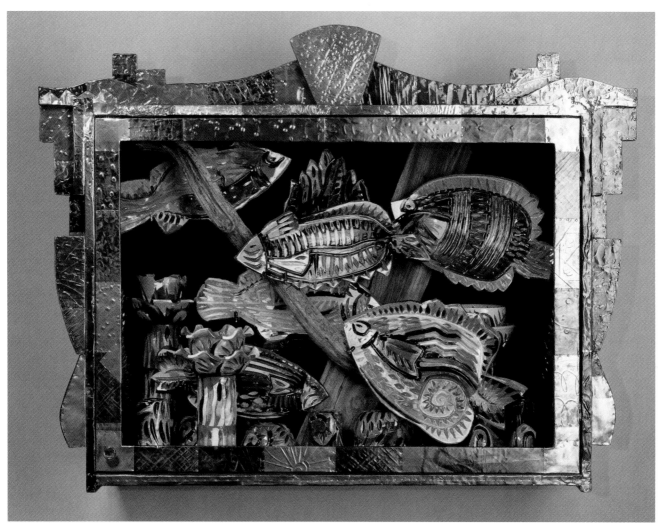

EDDIE DOMINGUEZ
Fish Dinner
Mixed media
37 x 48 x 12"
Courtesy Munson Gallery

range of idiom and materials. For example, a twenty-foot bronze buffalo may be found staring down an equally huge, pristine cube of steel in the minimalist vein.

In the vanguard of sculpture fabrication is Dwight Hackett's Art Foundry, Inc. Since 1980, the Foundry has worked with myriad New Mexico sculptors in realizing their work, no matter how challenging, and often in heretofore unusual materials, such as rubber, aluminum, wax, and iron. Attention has been brought to the New Mexico sculpture world by the Foundry through its work with some global art "stars" living and working here, such as Agnes Martin, Susan Rothenberg, Richard Tuttle, and Bruce Nauman. Other major figures producing

work there include Lynda Benglis, Robert Graham, and the late Roy Lichtenstein.

A champion of New Mexico's sculpture in the larger context of world art is SITE Santa Fe. A development of the 1990s, "SITE" is arguably the single most important development on the New Mexico art scene in the last quarter-century. With dedicated community and artist support, the SITE "Kunsthalle"/exhibition space, housed in a former beer warehouse in the town's railyard district, offers New Mexicans opportunities to measure their own sculpture and work in other media against work in the wider world.

A number of art dealers have been very important

to the promotion of sculpture by New Mexicans in recent years. In Santa Fe, those who stand head and shoulders above the rest in this regard may be numbered on one hand. Each, with a specific "eye" or sensibility, has fostered the careers of sculptors well-known locally and nationally. The support of prominent Santa Fe area galleries has brought acclaim to several innovative artists including Luis Jimenez and Jesus Bautista Moroles, Constance De Jong for her severe metal reliefs, newcomer Peter Sarkisian for his provocative video-installations, and to such figures as Tom Waldron, Peter Joseph, and Paula Castillo for their exceptional abstract sculpture. The nation's appetite for resolutely realistic public monuments has been stirred by the artist Glenna Goodacrc, most notably by her Vietnam Womens' Memorial bronze on the Washington Mall.

Any list of the "movements," ideas, or buzzwords which characterize sculpture today, in New Mexico and globally, is often bewildering. New Mexico has exponents of every conceivable idiom in contemporary sculpture. Of titanic scale, the major earthwork sculpture in the State is the still incomplete "observatory" of time and starlight, *Star Axis*, which artist Charles Ross has been carving out of a mesa in the wilderness near Las Vegas, NM, these past two decades. This Cyclopean undertaking will one day make it possible, in Ross's words, for the visitor to "sense the movement of the universe in relation to oneself."

Installation work, very "of-the-minute" these days, has a number of able advocates in New Mexico. Those who immediately spring to mind include Anna MacArthur, Tasha Ostrander, and Meridel Rubenstein. Women seem especially drawn to the medium. Rubenstein, moreover, is one of the handful of photographers locally who successfully conflate their camera work with installation, creating a marvelous hybrid.

The thought of kinetic sculpture immediately calls to mind the large scale, sometimes Rube Goldbergian contraptions hammered together by New Mexican Steve Barry. "They are works of the Luddite... denouncer of industry, smashers of machines," one critic has observed.

New Mexicans Steina and Woody Vasulka have been recognized all over the world for their seminal contributions in the field of video installation. Another local artist who has recently made a major splash in this rarefied realm, both here and in New York and Los Angeles, is the young Peter Sarkisian, whose assemblages of objects and video imagery verge on the surreal, or illustrate elaborate puns.

Assemblage, or the assembly of disparate found or fabricated materials into sculpture, flourishes in New Mexico. Key practitioners, each very different from the next, include Gail and Zachariah Rieke, Melissa Zink, Diane Armitage, Erica Wanenmacher, Paula Castillo and Gregory Horndeski.

In the abstract vein, in traditional materials and in experimental materials, a number of exceptional New Mexican sculptors have achieved considerable status and developed very recognizable styles. Leaving aside the New Mexico "pantheon" of world-renowned figures like Ken Price, Agnes Martin, Bruce Nauman, Richard Tuttle, and the late James Lee Byars, excellent non-objective work is being turned out, in the year 2000, by people like Stuart Arends, Larry Bell (a pioneer minimalist), Gloria Graham, Kevin Cannon, Patrick Mehaffey, Tom Waldron, Enrico Embroli, John Tinker, Tom Joyce, and Peter Joseph.

New Mexico has clearly joined the mainstream of world sculpture in the past 30 years, maturing from a provincial "art colony" to the status of a savvy player in the art dialogue which circles the globe in this new twenty-first century.

Jan Ernst Adlmann

Jan Ernst Adlmann is a Santa Fe-based art consultant, art historian, and former museum director/curator (Vassar College, Long Beach, Assistant Director, Guggenheim Museum, New York City). He is also the author of Contemporary Art in New Mexico (1996).

The connection of Asian Buddhism and the American Southwest may seem remote, but it is less so than meets the eye. Note the remarkable resemblance of New Mexico's wide-open spaces to the striking landscape of the Tibetan plateau and the great Silk Road regions where Buddhism and its art flourished so vigorously. Buddhism in its journey from the land of its birth has found fertile soil in the American Southwest, as is witnessed by the *stupas* – Buddhist monuments – that dot Santa Fe and the surrounding landscape. An increasingly large Tibetan community in Santa Fe and Albuquerque has brought the fluttering of prayer flags to New Mexico's community scenery, while a recent major show on Tibetan Buddhist art at the Albuquerque Museum brought a strong dose of the Asian spirit to local esthetic life.

Perhaps no art is so emblematic of the Asian spirit as Buddhist sculpture. For many in the West, the soul of Asia resides in the gently contemplative form of the meditating Buddha which found its greatest expression in India in the elegant and simple forms of the great golden age of Gupta sculpture (4th-6th c. AD). The Gupta ideal inspired endless permutations of the Buddha image in the varied styles of the art in the countries of the Buddhist diaspora, including notably Tibet, which developed its own interpretations of this timeless theme, such as the image of the Buddha Vairocana seen here (Fig. 1). In this sculpture we see the Buddha of the center, one of the five so-called "Dhyani Buddhas" or meditation Buddhas: he is shown with his hands in a variation on the gesture of teaching, his face in calm contemplation. Unlike earlier images, he is adorned with jewelry and ornaments, and in an extremely unusual detail, is represented fully clothed. The details of his clothing and boots are remarkable and unique, demonstrating the variation displayed in the many depictions of a theme so universal and general.

Buddhism originated in India around the person of the great sage Sakyamuni in the fifth century BC. It remained a faith without icons for the early part of its history: images of centers of pilgrimage such as trees and *stupas* – funerary mounds converted to centers of

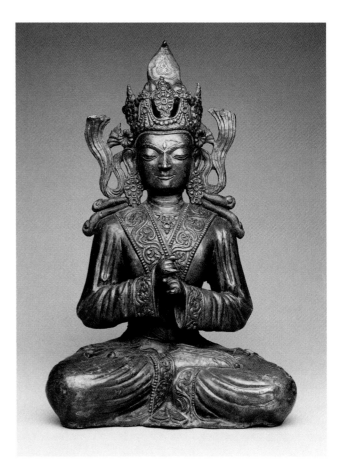

Fig 1 *Buddha Vairocana*, Central Tibet, Cast bronze, Approx. 12th Century AD, 16"H
Courtesy Peaceful Wind Gallery

devotion – took the place of images of the Great Sage himself. In the years surrounding the beginning of the Common Era, the first images of the Buddha appeared. In the early years of Buddhist iconography, images showed the founder of the faith either seated in meditation or at the moment of his enlightenment, when he touched the earth with his right hand to call it to witness his great victory over the forces of illusion. Later, the Buddha was shown in various elegant standing postures as well. These image types spread from India, the cradle of the religion, to all the great Buddhist countries: Sri Lanka, Thailand, Cambodia, Indonesia and the other areas of Southeast Asia to the South; China and Japan to the East; and Tibet and Mongolia to the North. The religion also traveled westward to what is now Pakistan

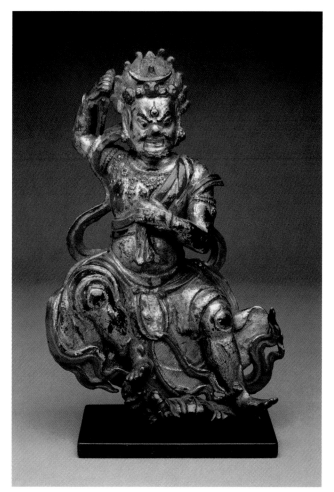

Fig. 2 *Guardian Deity*, China, Cast and painted/lacquered bronze, ca. 17th Century AD
10.5"H Private Collection

or "Diamond Vehicle" of Northern Buddhism, which incorporated imagery of sexual union and destruction in a further enriching of the visual life of this once simple religion. Peaceful images were joined by wrathful presences, such as the grimacing and gesturing protector figure from China (Fig. 2). Such figures were demonic energies that had been converted by powerful tantric priests to serve as protectors of the faith; they are often encountered as attendants of the Buddhas or *Bodhisattvas*, or as guardians of temple or monastery.

In this figure there is late evidence of a second esthetic strain in the development of Buddhist art. Whereas the earliest images of the Buddha himself were developed from a native Indian esthetic, simple, fluid, and idealized, this style was joined by a second which owes its origin to the art of Greece. Brought by artists who likely accompanied Alexander on his journey of conquest, this style, exemplified by the art of Gandhara, displayed the interest in anatomical detail and the combination of the realistic and the ideal pursued by the Greeks. In the energetic display of this sculpture this style still survives in a much later period, typified by the figure's prominent musculature, and the athletic gestures and stance. The type came to dominate the aesthetic of much Chinese and Japanese art: although Chinese in origin, the guardian figure seen here is often encountered in much the same guise in the sculpture of Japan.

Like the art of the tribal and native peoples, the work of Asian Buddhist artists was usually (though not always) left unsigned. This is less a reflection of the status and psychology of the artists – for evidence indicates that they were both proud of their skills and amply rewarded for them – than a question of a professional humility required of artisans who worked for the greater glory of the Divine World.

Ian Alsop

Ian Alsop is an independent historian of Himalayan art and cultural history who has published in various journals including Orientations, Arts of Asia and Artibus Asiae. He has also helped compile a dictionary of classical Newari and is editor of asianart.com, the on-line journal of Asian Arts.

and Afghanistan, where some of the great treasures of Buddhist art are still found. By the end of the first millennium, Buddhism had become the greatest religion of Asia, and had taken its place as one of the great religions of the world.

By this time, however, the religion had developed beyond the simple monastic philosophy of the early years. From the Theravada of original Buddhism, still practiced in the Southern centers, developed the Mahayana or "Great Vehicle" which embraced the idea of multiple sacred beings, the *Bodhisattvas*, who guided simple believers on their way to Enlightenment. The increasing complexity of the philosophy and teachings was mirrored in an ever-developing iconography. From the Mahayana developed further the Vajrayana

ANONYMOUS
UNSIGNED ART

Anonymous is a Santa Fe dealer in antique American Indian art. The following interview took place on January 1, 2000, the first day of the new millennium, at Anonymous' gallery in Santa Fe with the New Mexico Millennium Collection (NMMC).

NMMC: Why are you doing this interview as Anonymous?

ANON: It's an interview about unsigned art. It's not about me. By being Anonymous, I can give credit to the art we're talking about instead of taking credit for buying and selling it.

NMMC: How does that benefit you?

ANON: If the public recognizes unsigned art as a category, art collectors will appreciate the quality of the art I buy and sell.

NMMC: What's the difference between signed art and unsigned art?

ANON: Signed art is attributed to the artist who signed it. Unsigned art is attributed to the culture that created it.

NMMC: What does that mean, "attributed to the culture that created it"?

ANON: In most cases, when you don't have a signature, you can't attribute to an artist, so you attribute by culture. For instance, works of antique American Indian art are always unsigned, so attribution is by tribe rather than by individual.

NMMC: Is there that much of a difference between attribution to an artist and attribution to a culture?

ANON: There's all the difference in the world. When you learn about a work of signed art, you learn about the artist's life: who his parents were, where he lived, who else was painting while he was active, who he slept with and whether or not his kids had any talent. That's personal, biographical information, and it gives personality to the signed work of art.

NMMC: Personality?

ANON: A signed work of art always has an anecdote attached to it, like Van Gogh's self-portrait where he's missing an ear. Anecdotes reveal personality, the way a joke tells you something about the person who tells the joke.

NMMC: What about unsigned art?

ANON: Unsigned art is more arcane. Learning about a culture is not the same as learning about an individual. A culture is not about anecdotes. A culture is about war and peace, poverty and prosperity, slavery and freedom. When you research a culture, you look at religion, architecture, art, rituals, weapons and language. These are collective activities. They come from people, not from a person. Carl Jung's quote – "Dreams are personal myths; myths are collective dreams" – that's a good way of appreciating how related and, at the same time, how divergent signed and unsigned art really are.

NMMC: Is it more difficult to research a culture than it is to research an individual?

ANON: Researching a culture is certainly more challenging than looking up the biographical idiosyncrasies of an artist. Cultural data is harder to gather and more difficult to interpret than personal anecdotes. You can't interview a culture. You have to assimilate it through its language, its customs and its art.

NMMC: Where does unsigned art fit into the New Mexico art scene?

ANON: Unsigned art used to be the only game in town – not just in New Mexico, but all over the world. Signed art is a relative newcomer to the art world. Signed art is like English. It's spoken in a lot of places, but it's a relatively new language. Unsigned art is like Sanskrit. It's been around for a long time.

NMMC: What are the earliest works of unsigned art?

ANON: Probably the stone hand axes created during the Acheulean Period in the early Paleolithic era, between 650,000 to 300,000 BC. For the first 649,000 years of human history – and, obviously, those dates painter," where the artist – like a rock star – is just as

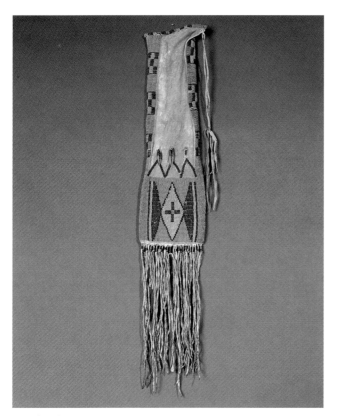

Arapaho Tobacco Bag
ca. 1880
30 x 6"
Courtesy Christopher Selser American Indian Art

hanging over the mantelpiece.) Art was something you between you and your habitat. That's why you see designs that resemble mesas, clouds, lightning and horizons on prehistoric storage jars. Those pots are models of the landscape in which they were created.

NMMC: When does prehistoric end and historic begin?

ANON: In the 16th century, when the Spanish arrive. The Spanish were smart. They were experienced colonialists. First they built a cathedral. Then they built a *mercado*, or market place in the shadow of the cathedral. Their strategy was to create a community among the Spanish settlers and the Native Americans. The *mercado* was where prehistoric Indian art got married to European aesthetic values. The child of that marriage was historic Southwest art.

NMMC: That's what happened here?

ANON: Yes. The place we call Santa Fe was a market long before the Spanish arrived, but the Spanish built that market into a commercial mecca. The Santa Fe Trail was the most important commercial trade route in the West. Santa Fe was its destination. If you lived within 500 miles of Santa Fe and you had something to trade, you came here. All of the pottery, jewelry, baskets and blankets bought and sold in Santa Fe between 1600 and 1900 were fusions of Spanish and Indian cultures, and all of that art was unsigned.

NMMC: What happened next?

ANON: By the first quarter of the 20th century, signed works of art began to appear. The Taos painters arrive, and they're signing their paintings. Maria Martinez is at San Ildefonso Pueblo, and she starts signing her pots during the 1920s. Margaret Tafoya is at Santa Clara Pueblo – she starts signing her pots during the 1930s. Georgia O'Keeffe arrives in the 1940s. In the 1950s, signed art takes over. Southwest art gets promoted and recognized as the work of individuals, not cultures. In the 1960s, Indian Market gets going, where everyone's an artist and every work of art is signed. In the 1970s, painters like R. C. Gorman, Fritz Scholder and T.C. Cannon create what comes to be known as "the Indian important as his art. Those painters paved the way for

are estimates – art was neither signed nor dated nor titled. It's only during the last thousand years that The Artist has come into the picture. Among Native American tribes, until the 20th century, there were no words for "art", "artist", or "religion", because those realities were not distinct from each other.

NMMC: Talk some more about unsigned art in the Southwest.

ANON: If you begin with the Clovis points and move forward through Anasazi baskets, Anasazi pottery, Mimbres pottery and Sityatki pottery, you realize that art in the Southwest has always been associated with daily life. Art appears in the forms of utilitarian objects – storage jars, winnowing trays, wearing blankets – objects that increased people's chances of survival. People made art, and art kept them alive. Art was essential. Art was a tool. (Art was not simply a painting of a cavalry officer did to the earth, and with the earth. It was a partnership

many galleries in Santa Fe that now sell signed art.

NMMC: So, what you are saying is that a signature becomes more and more important?

ANON: Exactly. If you want to know how much a signature means to a work of art, go into a painting gallery and ask to see their unsigned paintings. You know the expression, "making a name for yourself?" That's what artists and art galleries do. They make names, because names makes money. Forrest Fenn, one of the most successful painting dealers in the history of Southwest art, had a saying: "I'd rather have a bad painting by a great artist than a great painting by an unknown." That says it better than I can.

NMMC: Do you dislike signed art?

ANON: No, it's not that I dislike signed art. It's that I'm drawn to unsigned art. I like living with it. I like the way great works of unsigned art get better over time.

NMMC: And your clients share your preference?

ANON: I can't speak for my clients. But I have noticed an interesting tendency among clients who collect Indian pottery. Almost all the pottery collectors I've met started out collecting contemporary Pueblo pots with signatures – the kinds of pieces you find at the museum gift shops. Then they moved on to established Indian families of artists, like the Martinez Family at San Ildefonso, the Tafoya Family at Santa Clara, the Nampeyo Family at Hopi, or the Quezada Family at Casas Grandes. Finally, after they got tired of the families' pottery, they moved on to unsigned, historic pottery or, in some cases, to prehistoric pots. I've seen that evolution of preference occur a hundred times. What's interesting is that, in twenty years of doing this, I've never seen it go the other way. I've never seen a collector of historic or prehistoric pottery sell their older material and move into new pieces.

NMMC: Why do you think that is?

ANON: Well, again, the unsigned material asks more of you as a collector. And, like most works of art that require something of you, unsigned art rewards you for your appreciation once you understand it. It's like the

difference between reading a John Grisham novel and going to a performance of Hamlet. You're not going to have any trouble following Grisham. He's going to let you know where things stand from Page One. But, when you get to the end, you're the same person you were at the beginning. The novel was suspenseful, no question, but it didn't haunt you or change your life. With Hamlet, on the other hand, you can get halfway through Act Two before you're sure of who the characters are or of what's happening to them. But, by the end of the play, you're so caught up in their lives, and their destinies are so real, you can't stop thinking about them. The play is in your mind, not just on it.

NMMC: Does unsigned art have a deeper message than signed art?

ANON: No, I can't say that. There's a lot of great signed art in the world that could keep me spellbound for the rest of my life. What I like about unsigned art is the way it demands something of you. It doesn't always offer immediate gratification. But, over time, a work of unsigned art teaches you as much about yourself and your culture as it does about the culture that created it. In that sense, unsigned art is like good abstract painting. A picture by Mark Rothko may have no literal meaning, per se, but the experience of looking at the painting and considering what it does or doesn't mean can be a powerful experience.

NMMC: Even though it's a signed painting.

ANON: Great art is always great, signed or unsigned.

NMMC: Where are the best places to see unsigned art in New Mexico?

ANON: The Museum of International Folk Art. The Girard Collection, Spanish Colonial Wing and Cotsen Collection – each of MOIFA's wings could be a major museum all by itself. In Taos, the Millicent Rogers Museum, and in Albuquerque, the Albuquerque Museum which is highly underrated.

NMMC: How about galleries?

ANON: Canyon Road has several important galleries

for unsigned art. The Elkhart collection and Morning Star Gallery both have great American Indian material. Ron Messick Fine Arts has excellent pre-Columbian and Spanish Colonial material. Christopher Selser is an old friend and has beautiful American Indian art. And Conlon Siegal has the best collection of South American textiles for sale anywhere in the world.

NMMC: What about downtown?

ANON: Peaceful Wind has museum quality Asian art, and they handle the best Tibetan furniture I've ever seen. Seret & Sons has a huge inventory of Oriental carpets and furniture, and Ira Seret is a guy you have to meet if you want to experience unsigned art in Santa Fe. On the Paseo, Clarke & Clarke has excellent African and Oceanic material. The Dewey Gallery has fine Indian pottery, rugs and jewelry. Tad Dale is one of the most honest dealers in unsigned art anywhere in the world. And Joshua Baer & Company always has a special collection of Navajo blankets and rugs.

NMMC: Why is Santa Fe a center for unsigned art?

ANON: Santa Fe attracts eccentric, risk-oriented people: entrepreneurs, traders, self-made men and self-made women. People who take risks in business take risks in collecting. If you think about it, a signature is like a warranty attached to an appliance. It makes you think you can get your money back when the time comes to sell. A signature assures you that what you're buying is considered to be beautiful and valuable, even if you don't know how to assess beauty or value. A signature lowers the risk.

NMMC: Unsigned art doesn't have its own guarantees?

ANON: You can get guarantees of authenticity, sure. But unsigned art requires you to look at the art, not at the artist. For the average art collector, that's a risk. It means you have to covet the art itself, not the prestige or social approbation that comes with owning a Picasso, a DeKooning or a Warhol. But entrepreneurs don't like to play it safe. They avoid guarantees. Entrepreneurs understand that a consensus is a collective opinion with most of the value pumped out of it. They go against the

consensus. One of the best things about unsigned art is that it's a better deal than signed art. Masterpieces of unsigned art cost less than signed masterpieces, because there are fewer dollars competing for unsigned art than for signed art.

NMMC: So unsigned art is art for contrarians.

ANON: Well, some contrarians. If every contrarian wants the same thing, then they're not contrarians.

NMMC: Care to make any predictions about the values of unsigned art?

ANON: The financial markets are telling us that innovative, entrepreneurial businesses are going to grow faster than traditional, bricks-and-mortar businesses. If the markets are right, entrepreneurs are going to accumulate more disposable wealth than conservative investors. Entrepreneurs like unsigned art. Unsigned art costs less, on the whole, than signed art. If you do the math, you have to conclude that the best works of unsigned art are going to have larger and larger amounts of money competing for them. You have to buy carefully, but I think the best works of unsigned art are selling for a fraction of what they'll be worth in five years.

NMMC: You're a specialist in American Indian art. What distinguishes American Indian art from other kinds of unsigned art?

ANON: I don't know enough about pre-Columbian, African, Asian or Oceanic art to answer that question. But I will say this. We live here, in the Southwest, and some of us really love it here. I think the art you collect ought to reflect your passions: where you live, who you love, all those things. Once you get attached to this part of the country, you find yourself drawn to works of art that distill and reflect your appreciation of this landscape. For me, the landscape here and the older Indian pieces are one and the same. They explain each other. It's a subjective point of view, but that's where my passion lies, for better or for worse.

JOHN FINCHER

TURN IN THE ROAD

Oil on canvas
82.25 x 57.75"

John Fincher is one of the most highly regarded of Santa Fe's longtime resident contemporary artists. His painting style is nominally representational, yet his inclusion of elements such as grids and subtle architectural elements take his work into a postmodern arena. His rich impasto and forceful brushwork convey the blistering intensity of the landscape and the skies. Travels to Egypt, the Orient, and Provence, and the resulting works of art, keep him from being readily categorized. His choice of subjects, which has at times included collage, postcards, brass rings, cactus forms, and iconographic shaving brushes, keeps him on the constantly shifting edge between traditional and avant garde.

John Fincher has enjoyed steady recognition throughout his career. Many major corporations have collected his work. His art has been shown in museums throughout the United States, where it hangs in permanent collections, and in international touring exhibitions.

FLORENCE PIERCE

UNTITLED, FIBERS & GREEN #301

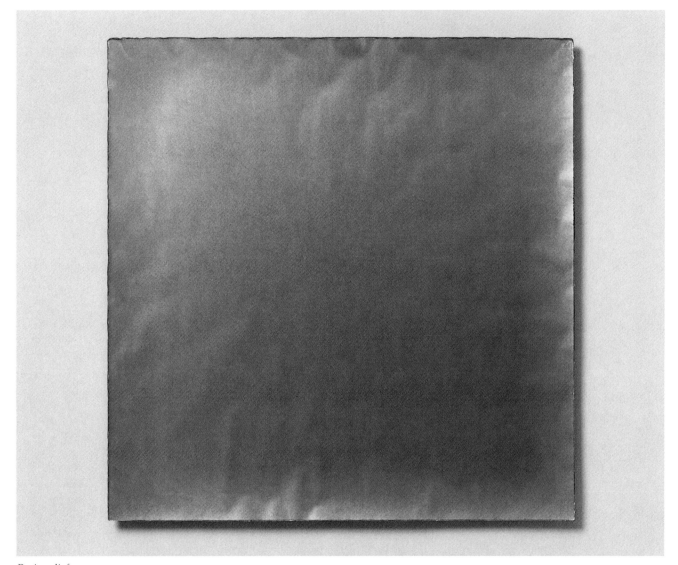

Resin relief
24 x 24″

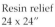lorence Miller Pierce became the youngest member of New Mexico's Transcendental Painting Group in the late 1930s. Today, more than half a century later, she continues to sail effortlessly out ahead of the trend. Her work combines painting and sculpture in a pristine artform of translucent resin poured on reflective surfaces, with edges shaped to the idea at hand. These minimal pieces are hung on the wall like mirrors of the subconscious, drawing in each idea that comes before them and giving it back as complex, delicately restructured, pure light.

Florence Pierce is a master of poured resin, a medium so demanding in sheer physical terms that few people of any age attempt it. She has such an affinity for it that she thinks about it even when she is not pouring. She colors it in the richest imaginable clear primaries, sheaths it in metallic veils, or draws back to a white on white surface that is shot through with subtleties of flickering light. Her art has been featured in solo museum exhibits and important group shows, has entered major collections, and has taken her to the zenith of critical acclaim.

ROBERT KELLY

TREE OF CONSANGUINITY XXXVIII

Oil/mixed media on canvas
80 x 64"

Robert Kelly is a native-born Santa Fean who maintains studios in New Mexico and New York. Using a variety of paints and solvents, bonding images of the past to the canvas, and placing symbols born of French curves, Kelly creates technically complex works that appear almost seamless in their construction. He travels extensively, collecting antique papers and other materials for reference and use in his work. Since receiving his B.A. from Harvard in 1978, Kelly has had numerous solo exhibitions in the United States and Europe. His paintings are in the permanent collections of the Brooklyn Museum, the Museum of Fine Arts in Santa Fe, the Milwaukee Art Museum, DuPont and Company in Delaware, IBM and Phillip Morris in New York, and Chemical Bank in London, as well as other museum and corporate collections.

MELISSA ZINK

VOLUME VI: RUSTING

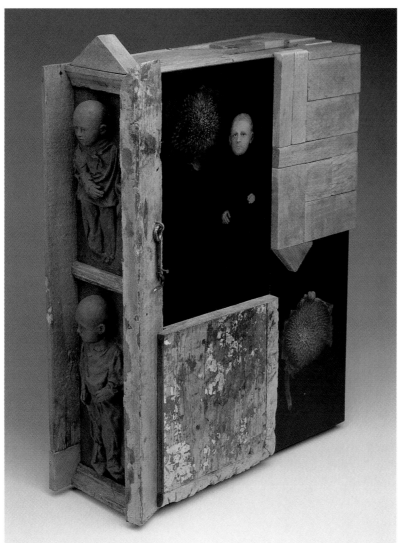

Mixed media
19 x 14 x 4"

Melissa Zink's current works are combinations of painting, sculpture and mixed media that serve as equivalents to what the artist thinks of as the book experience. "The center I have been circling around and around is a private aesthetic formed from books and by books," she says. "That aesthetic developed from the act of reading, the memories of reading, the literal companionship of books, the enchantments of photography, typography, graphic design, paper, leather, etc."

In her series of *Volumes* Zink offers a "novel" choice. The pieces, which are roughly proportional to books, are designed to either project from the wall or stand on a pedestal. In either case, the viewer must move about the piece, viewing it as one would browse through the pages of a text.

Many of Zink's pieces, which are included in numerous museum, corporate and private collections, contain references to what she describes as "the lights of my life," from Hans Holbein and Dieric Bouts to Francis Bacon and Max Ernst. Senses of awe, mystery and kinship are evoked through the artist's immaculately rendered oil glaze paintings, mixed media sculpture and "appropriated" scraps of old wood, tin and book bindings used to create the bodies of the works.

Georgia O'Keeffe 1887-1986

Winter Cottonwoods

Georgia O'Keeffe is one of the monumental historical figures in American art whose tenacious, candid personality has piqued as much interest as her memorable painting style. A woman born in the nineteenth century, O'Keeffe's spirit was decidedly in the twentieth. Her style, located somewhere between abstraction and realism, is simple, yet dramatic and layered with meaning. A common thread running through most of her production is her intense affinity with and celebration of nature's subtle nuances.

O'Keeffe was born in Sun Prairie, Wisconsin. In the autumn of 1905, she enrolled at the School of the Art Institute of Chicago, and later studied under William Merritt Chase at New York's Art Students League during 1907 and 1908. Between 1911 and 1918, O'Keeffe taught art at schools in Virginia, South Carolina and Texas to support herself, intermittently taking the time to further her own art studies. Perhaps the greatest early influence on her art came from her studies under Arthur Wesley Dow at Columbia University's Teachers College in New York. Dow, a teacher and collector of Japanese art, favored simplified, abstract expression and Eastern aesthetics over traditional Western painting techniques.

In January 1916, O'Keeffe's early charcoal experiments in abstraction were brought to the attention of photographer/modernist patron Alfred Stieglitz in New York. Prominent through his own work, Stieglitz was already a legendary champion of modern art through his writings and his New York gallery, "291." The ensuing association between O'Keeffe and Stieglitz was of incalculable importance to O'Keeffe's career in particular and to American modern art in general. Stieglitz was behind O'Keeffe's decision to stop teaching, her move to New York, and her pursuit of painting on a full-time basis. Stieglitz was her greatest mentor, and became her husband in 1924.

O'Keeffe passed through New Mexico in 1917 on her way to Colorado, but it was her 1929 journey to Taos with Rebecca Salsbury James to visit Mabel Dodge Luhan that truly changed the course of her life. She returned to New Mexico almost every summer thereafter, finally moving to Abiquiu in 1949, three years after Stieglitz's death. The paintings that preceded and followed this move to the Southwest indelibly linked O'Keeffe to New Mexico, and ensured her place as one of America's greatest artists.

Winter Cottonwoods, 1951 is a striking example of one of O'Keeffe's late series in which she painted the feathery, misty cottonwood trees lining the Chama River in Abiquiu, New Mexico at various times of year. Executed roughly between the years of 1943 and 1956, these tree paintings place the main arboreal subjects – expressive, arabesque tree limbs and branches that swing and sway – against colorful or pastel-hued backgrounds. In contrast to her solid architectural abstractions and hard-edged bone paintings of this same era, these cottonwood paintings are animated and weightless, and highlight a softer side of the mature artist's talents.

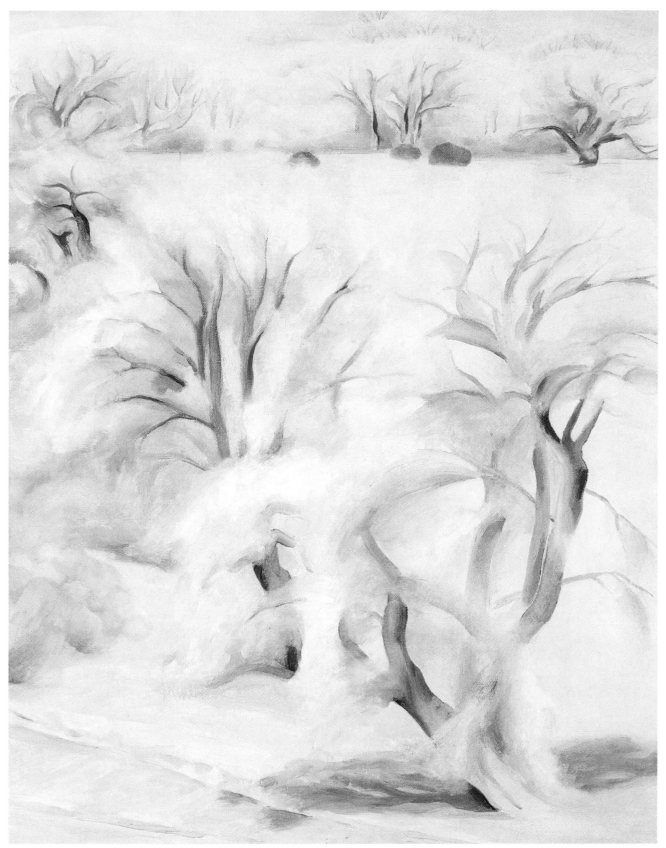

Oil on canvas, ca. 1951
26 x 21"

MARIA MARTINEZ 1887-1980

SAN ILDEFONSO PUEBLO

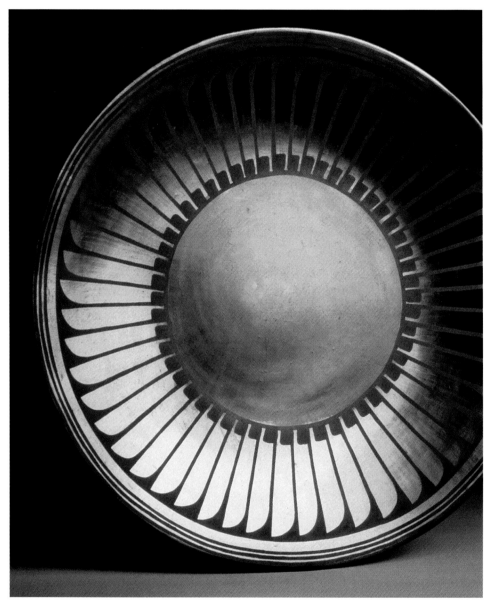

San Ildefonso black plate
12"D

Maria Martinez was known primarily by her first name, Maria. She lived her entire life at San Ildefonso Pueblo, north of Santa Fe. It was she who was responsible for reviving black-on-black Pueblo pottery in the mid-twentieth century, and for attracting the attention of museums and collectors. Her tireless efforts not only contributed greatly to her own village, but effectively put all Indian arts and crafts on the map.

Maria also made polychrome and black-on-red pots. Her hand-coiled vessels, built without a potter's wheel, were finely polished and perfectly symmetrical. The surface decoration was usually done by her husband Julian, her daughter-in-law Santana, and her son Popovi. One of the most famous Indian artists ever, she continues to inspire others through the brilliant body of work created in her lifetime.

MAYNARD DIXON 1875-1946

NAVAJO LAND

Oil on canvas, ca. 1925
25 x 30"

Oil on canvasboard
20 x 24"

WINDMILL

Maynard Dixon painted the American Southwest on its own terms. Deeply connected to the deserts, he traveled over them in automobiles and buckboards, on horseback and on foot, setting up camp and immersing himself completely in the task of observing and understanding what he saw. As a result, he was able to capture the elegant austerity and the mighty sweep of the land-scape as few other artists have ever done.

Dixon was a prolific easel painter, illustrator, muralist and poet who wrote eloquently of the desert's "golden dust ... broadcast over the sun-lands." He achieved success and critical recognition in his lifetime, securing his prominent place in the history of American art.

NAVAJO

CLASSIC SERAPE

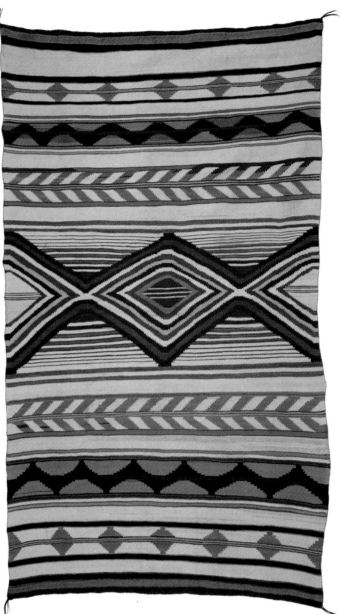

ca. 1840-1860

Navajo weavings are among the most prized relics of Native American life before and during the advent of early Spanish and Anglo-European traders and settlers. This mid-nineteenth century Navajo Classic Serape, created at a time when such arrivals were still somewhat rare, is an all-vegetable dyed plain weave in native handspun and 3-ply and raveled fibers.

This piece is ranked among the most important and historically significant examples of Navajo ethnographic textiles. In its structure and design, the educated eye can detect various cultural trends as they were impacted by other Indian and non-Indian groups. New ideas came in along with imported fibers and dyes, and the creative weaver incorporated the best of these into personal statements that evolved with the times. As other Southwestern artists, including those working in ceramics, developed motifs based on prehistoric Pueblo textiles and Anasazi pottery, these influences also crossed back and forth from one medium to another.

A YAH NAL SOSIE

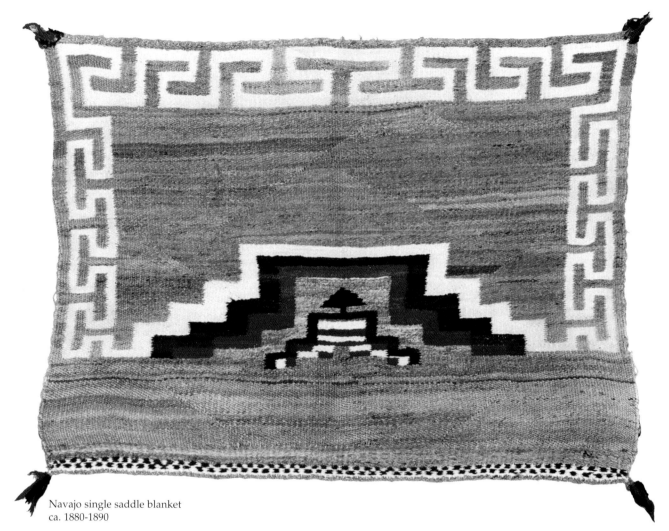

Navajo single saddle blanket
ca. 1880-1890

A Yal Nal Sosie is the name of what was probably the first saddle blanket used by the Navajo. It was used as a top cover or saddle throw in conjunction with sheepskins and saddle frames. Sheepskins soon began to be used less frequently, and a larger sized blanket took their place. It was known as the single saddle blanket.

The art form of the blanket became the palette of the next generation of saddle blankets, known as the double saddle blanket, or *Ak Idahi Nili*. The Navajo were proud

of their mounts and took great pride in the creation of fancy saddle blankets to adorn them.

The custom saddle blanket was in high demand by cowboys, both rich and poor, for the beauty of the textile, which was adorned with geometric patterns, pictorial images, and sometimes their livestock brands. Last but not least they were used for cooling purposes, for the care and comfort of the animal.

ANI YELLOWHAMMER

MEDICINE MAN SERIES: INITIATION

Oil, gold leaf/panel
40 x 50"

Ani Yellowhammer studied art at William & Mary College and the Malden Bridge Art School in New York. After raising her three sons, she relocated to New Mexico in the 1980s to pursue her art career.

The catalyst for this series was the death of Mr. Yellowhammer, an Oklahoma Medicine Man and long-time friend who had been teaching Ani old medicine ways. The Medicine Man paintings are instantly engaging; they are windows inspired by contemplation and meditation; visual mantras created with repetitive imaging and rich warm color over gold leaf with veils of transparent glazing. The paintings have a resonant aura that achieves a balance of active and passive energy. The paintings are not static, but react to light and tone as the ambient light changes and gives each painting a unique life. The Medicine Man paintings achieve a satisfying sensibility of color, balance and focus.

"My work is about light; surrounding, coming from, going beyond, creating beauty." – Ani Yellowhammer

JOE RAMIRO GARCIA

BLUE MUSE

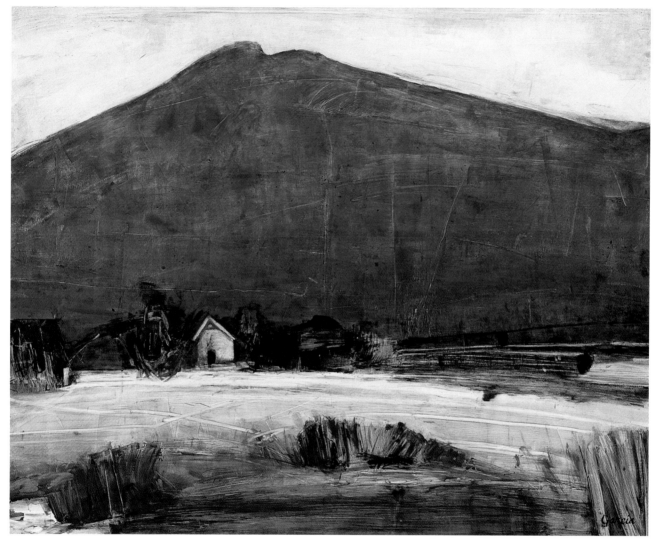

Oil/linen
48 x 60"

Joe Ramiro Garcia's spirited paintings and monotypes delight the senses with joyful sensuality and dynamic color. His works encompass an expansive range of subjects, including still lifes, birds, landscapes, flowers, and horses. He is possessed of a passionate, romantic edge that draws viewers into his images.

"I like to encourage people to visually participate in my artwork," says Garcia. "People often see meanings and visions in my art that are not intentional, but always exciting. That interaction with my viewers encourages me to trust my creative instincts. It gives me permission to create without limits."

Garcia studied at the School of the Art Institute of Chicago in Illinois. Since 1987, he has lived and painted in New Mexico. His art is in private and corporate collections in Australia, the Dominican Republic, Mexico, Canada and throughout the United States.

Joe Ramiro Garcia constantly strives to redefine and challenge the parameters of his art. "To be lost in the process of creating is one of the best things in the world," he says.

PAULA CASTILLO

DISTANCE BETWEEN STARS

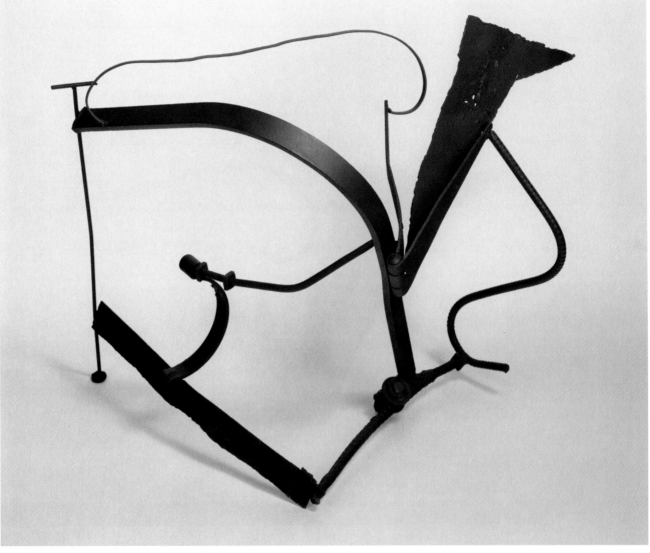

Metal
33 x 23 x 25"

Paula Castillo went forth from a small town in New Mexico to study at Yale University, then returned to graduate from the University of New Mexico. She married poet Terry Enseñat Mulert and the couple lived, worked, and taught in Germany for several years, traveling extensively throughout Eastern and Western Europe. They returned to the United States and Castillo and Enseñat Mulert opened their art gallery in Cordova, New Mexico. Castillo was awarded research fellowships by the National Endowment for the Arts and the National Science Foundation to study various aspects of sculpture. Her work is exhibited at major galleries across the United States, and her solo shows have met with critical acclaim. She is completing a monumental commission in her home town of Belen for New Mexico Arts in Public Places.

"I work with gravity and temperature and light," says Castillo. "They are as abstract as they are pervasive. When I create art everything is stripped to essentials ... I continually look for things that surprise me."

SHEILA KEEFE

JOURNEY OF THE PEREGRINI I

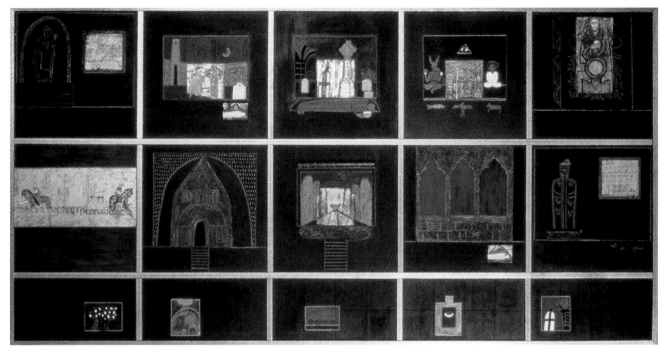

Mixed media
31 x 62"

Sheila Keefe works with strong images and complex themes. She uses a wide variety of materials, carving and painting them in order to convey exactly what she intends. Wood, fabric, gold leaf, and heavily textured mediums define sculptural elements and contrasting areas. She is particularly concerned with light. To put it forward, she sometimes uses black, which is a notoriously difficult color with which to work. In her hands, however, it functions perfectly, because she considers it a warm and enveloping color that allows the light to emerge.

Sheila Keefe, originally from the Washington, D.C. area, has traveled to Rome, Mexico, and other beautiful places, but she also finds inspiration in her home surroundings of northern New Mexico. "I love every place I've ever been," she says, "but this is the only place I've ever wanted to keep coming back to." She is very interested in the religious art of the area. Her jewel-like contemporary paintings suggest altarpieces, whether their subject is sacred or secular. "I always start my work from a place of silence," she says. "And that's why I like living in New Mexico. This is a place where I get all the silence and solitude that I need."

BARBARA MCCAULEY

YELLOW LIGHT

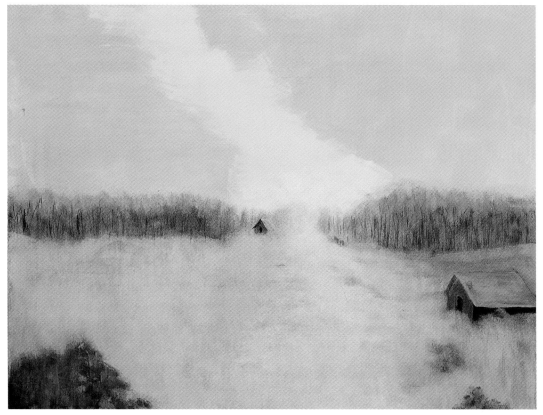

Acrylic on canvas
30 x 40"

arbara McCauley's style balances on a taut sense of realistic expressionism. Her vision rests on what remains hidden, on the stuff of things behind things. In luminous landscapes, a human presence is felt rather than seen in expressively still houses. barns or outbuildings. Inspired by artists Vermeer, Diebenkorn, Kahn and Hopper, among others, McCauley pursues light and line as her first concerns.

Composition, color and subject arise out of these two elements.

Cardona-Hine and McCauley met in Los Angeles in 1967 when she joined a poetry workshop led by him. They now share their art and lives in Truchas, New Mexico where they have their studios and a gallery in which to show their work.

ALVARO CARDONA-HINE

lvaro Cardona-Hine has been practicing three disciplines for over fifty years. As with his musical composition and writing, his painting cannot be easily categorized. His style in his now famous bird paintings is most often lyrical or whimsical, while in his large mythic paintings, powerful figures command the canvas and the palette deepens

along with the subject. His landscapes are sometimes equally dramatic; at other times they reflect a shimmering poetry of abstract beauty. Beneath Cardona-Hine's several approaches is the bedrock of a highly intuitive painter whose depth and breadth of vision cannot be encompassed in a singleness of expression.

ISIS

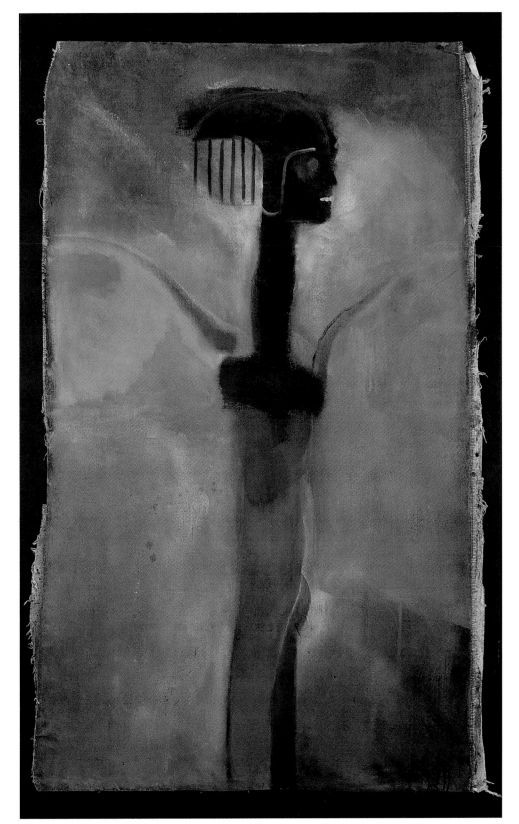

Acrylic on canvas
78 x 48"

MELINDA K. HALL

TIGER, SLIGHTLY WILD

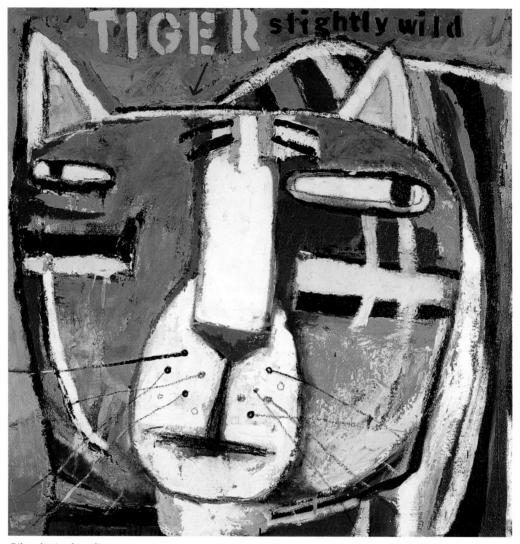

Oil and mixed media on canvas
28 x 28"

Melinda K. Hall's work hovers between that of the true Outsider, who rests on the fringe of culture and society, and that of the educated mainstream painter. It is forged from the unfettered expanse of the intuitive artist's imagination. Hall's work depicts the themes typical of the direct expression of the self-taught; her sophisticated surfaces and painterly execution establish her solidly as an accomplished professional.

Animals from a peaceable kingdom, be they colorful canines and cats from her own backyard or a tiger from a terrain she has never seen, saunter across Hall's canvases. Her thick-here-soupy-there signature style and her quirky sense of humor entices viewers into the subtle interplay of surface, composition and imagery. Hall's perspective on a woman's role in family and society may be discerned in an almost-self-confident woman of Amazonian proportions, or in a childlike line drawing that gleefully does a little "Barbie bashing."

Since 1992 Hall's paintings have been displayed in numerous one-person and group shows in both gallery and museum venues. Her work currently hangs in private and corporate collections worldwide.

JIM ALFORD

GALLERY 2000

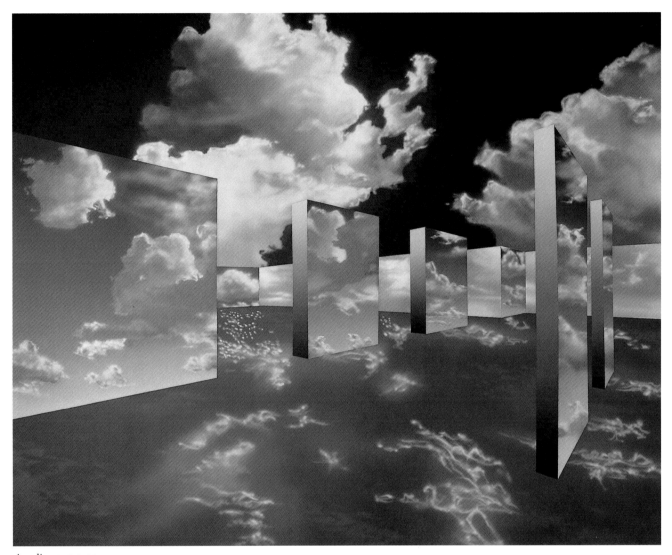

Acrylic on canvas
48 x 60″

J im Alford is a student of the sky. His paintings are a montage of special moments collected from the skies surrounding his home and studio on the plains south of Santa Fe. When Alford placed mirrors in the sand dunes thirty years ago, it started an evolution. Gradations of light and sky reflecting in the sand led to towering mirror sculptures and monoliths on the New Mexico plains, still capturing the drama of the sky. This trajectory of reflections now goes beyond actual mirrors into the digital realm, where, by using the computer as his sketch book, Alford can create landscapes of his imagination on canvas.

Jim Alford is a painter, photographer and digital image maker from Santa Fe. In 1993 he was selected to be a member of the N.A.S.A. art team and his paintings are a part of N.A.S.A.'s permanent collection. In 1995, Alford won the Kodak KINSA photography competition, considered the largest photo competition in the world.

DAVID PEARSON

MISHNA

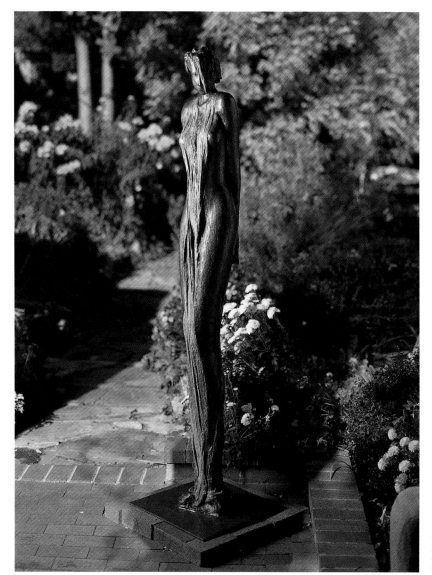

Bronze
Ed. of 9
60 x 10"

David Pearson has been sculpting for over twenty-three years and has become a master of his craft. His sculptural style is often elongated and ethereal, at other times more realistic, and always uses the figure as subject. Bronze mummies reminiscent of ancient Egyptian excavations and sleek, dignified women generate a quiet intimacy between sculpture and viewer.

A self-taught artist, Pearson began his career at the age of sixteen apprenticing at Shidoni Foundry in Tesuque, New Mexico. His career developed as he became director and sculptor at the Art Foundry for ten years and participated in collaborative efforts. The great experience he gained as patina master and mold restorer for the Allan Houser estate has been invaluable in his individual career.

Fascinated by early cultures and forgotten words, Pearson uses this curiosity to fuel his inspiration and fill his creations with mystery. The sculptures have an austere yet peaceful presence in common. He incorporates textural qualities and a variety of patinas to create contrast and depth within a piece.

His work can be seen in a variety of environments including international collections and museum shows.

HENRIETTE WYETH 1907-1997

FLOWER FANTASY

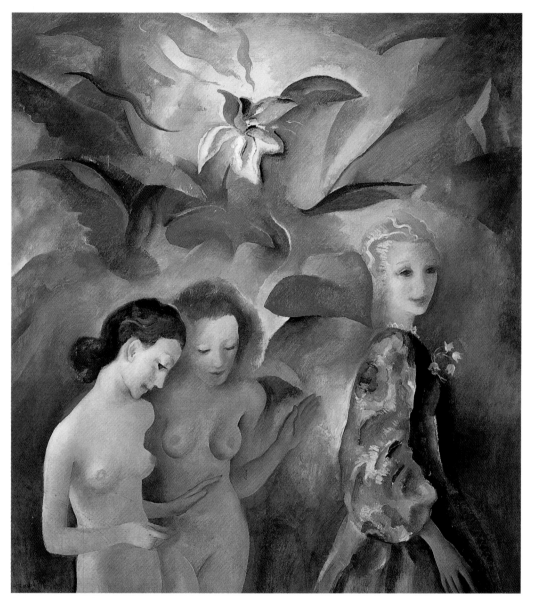

Oil on canvas, 1925
49.5 x 45.5"

Henriette Wyeth was a member of a family of American artists that included her famous brother Andrew Wyeth and their father, N.C. Wyeth, as well as today's third and fourth generation artists. Her father encouraged creativity in his children, sending his daughter Henriette to study in Boston. It was there that she encountered the theater and the blue stage lighting that transformed the painted sets. This ignited a private world of the imagination that she called her "great appetite for the artifice of blue light," a subject she treated a number of paintings. She became widely recognized for her portraits and her lyrical paintings of flowers. Her work hangs in many museums, including the National Portrait Gallery at the Smithsonian, and other public and private collections.

Henriette Wyeth married native New Mexican artist Peter Hurd in 1929, and the couple moved to San Patricio in southeastern New Mexico.

LUBA DIVINATION FIGURE

EASTERN ZAIRE, AFRICA

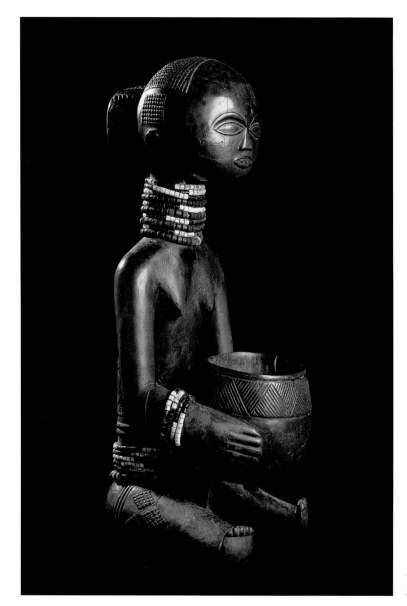

Wood with trade beads
31"H

Bowl Figures have historically been created by the Luba people of Eastern Zaire. The figures are owned by both chiefs and diviners who wish to honor and remember the critical role played by the first mythical diviner, Mijibu wa Kalenga, in the founding of kingship. Rulers keep them at their doors, filled with a sacred white chalk associated with purity, renewal and the spirit world.

This example, however, indicates the figures' more common role as the prerogative of royal diviners, called *Bilumbu*, who use the bowl figures as oracles and as receptacles for the possessing spirit's wife. The female figure holding this bowl bears the marks of civilization in her scarification, elegant coiffure, filed teeth and beaded *accoutrements*. The lustrous patina indicates years of ritual bathing with palm oil or cocoa butter, intended to honor the spirit who may choose to reside in the figure and act as the diviner's intermediary.

These figures make an extraordinary addition to any ethnographic collection.

DAN NAMINGHA

FOUR CARDINAL DIRECTIONS

Acrylic on canvas
64 x 60"

Dan Namingha's status as an international artist has all but eclipsed his reputation as a preeminent Native American painter and sculptor. A Tewa-Hopi, he is a descendant of the Anasazi, the ancestors of the Pueblo Indians. Drawing upon classic themes, Namingha creates canvases and bronzes that address such contemporary issues as the fragmentation of society as a whole. He explores the dualities of life—philosophical, emotional, and intellectual – using ancient symbols and a strong style that grows ever more dazzling in its complexity. In Namingha's work, form and meaning become one.

Namingha, a member of the Nampeyo family of artists, grew up on the Hopi Reservation in northern Arizona. His strongest imagery comes from his early impressions of the severe landforms, the pueblo architecture, and the ceremonies that are the basis of community life. The kachinas, the four directions, the spiral migration symbols, and many other abstract elements make up his unique visual language. He was also profoundly influenced by the giants of modern art. Picasso, deKooning, Rothko, and others explored American Indian motifs, and Dan Namingha brought them full circle. His art is included in countless public, corporate, and private collections. Special awards and solo museum exhibitions have consolidated his global importance.

JAVIER LÓPEZ BARBOSA

AWAITING DISCOVERY

Oil
24 x 20"

J avier López Barbosa is known for his vividly colored, emotional abstractions that reflect the viewer's own thoughts. Barbosa creates a glossy surface that brings up the depth and nuance of each detail, much like the effect of pooled water in a riverbed. A self taught, lifelong artist from Guadalajara, Mexico, he lives with his family in a lovely home that he and his wife built in the hills near Santa Fe.

NANCY ORTENSTONE

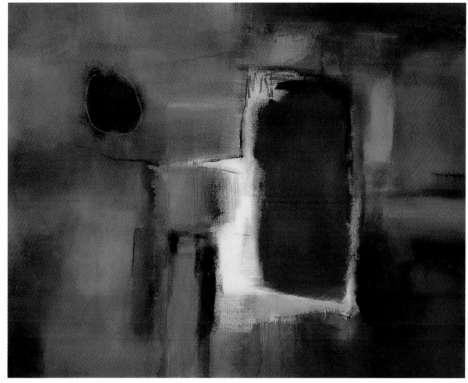

IN HARMONY

Nancy Ortenstone's soaring abstract paintings resonate with inner meaning. Each atmospheric meditation on music, dance, or architecture is structured to evoke a different response. "In my work," says Ortenstone, "the vibrations of color and light create something else, a feeling beyond the immediate image. It is a matter of harmonics, of tuning the spaces to reflect each other."

Acrylic
46 x 58"

RUDI KLIMPERT

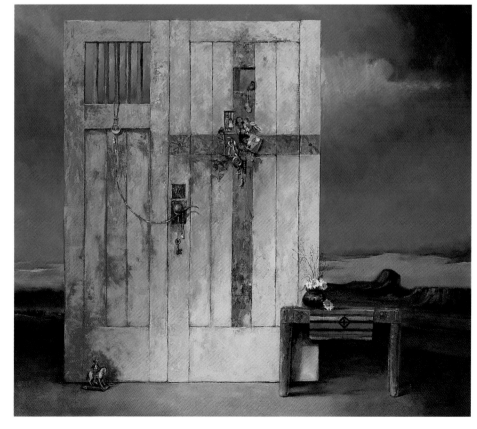

WAITING MEMORIES

Rudy Klimpert paints modern Southwestern icons. Using landscape, symbolism, history, and ethnic artifacts, he conjures up the distinct multicultural experience and the radiant mystery that is New Mexico. "If one could open one of my doors and walk through it rather than around it," Klimpert notes, "one would encounter a specific experience that illuminates the beauty of this region."

Oil
44 x 50"

PENNY SISTO

BELOVED SON - LITTLE BEAR

Penny Sisto creates studio quilts that mirror her life experiences. To stand in the middle of a gallery filled with the work is to come face to face with the full impact of the richness of her deeply felt emotion. More than thread is woven through the fabric of Sisto's work as she reveals the bright beauty and the dark secrets of the many years spent as a midwife with the Masaai tribe of Africa – a culture that Sisto describes as "the most beautiful people I had ever seen."

Born on the remote Orkney Islands off the northern coast of Scotland, Sisto was raised by her grandmother who taught her to sew and to read at the age of three. When she was still a young girl, a face to face encounter with a handsome gypsy ignited a desire to put down in fabric what she had just seen. Taking snippets of drapery and her grandmother's lace, young Penny, who was decidedly punished for helping herself to precious bits of fabric, created what would be the first of thousands of art quilts – art quilts that have found their way into many major private and public art collections through fine art galleries. "The inspiration for most of my quilts comes from my experiences in Africa, but they are really universal," explains Sisto. "In the piece we have here, called Beloved Son-Little Bear, you will see that the hands almost touch, but not quite, as there is always a wee gap between mother and son; between man and woman. The journey of our lives is to actually touch."

Sisto's "beings" are first brought to life when faces are "found" in large pieces of dyed or painted fabrics spread out on a work table in her studio... a space she refers to as the "birthing table." Her work seamlessly blends images of people, animals, and objects to create otherworldly pieces that draw viewers into a place most have never been before. She chooses fabric as her medium for that very reason. The familiarity of cloth – the very thing we were wrapped in at birth – actually pulls people to it, making them step toward the work as they examine it, rather than stepping back as is typical when eyeing a painting.

"Quilting excites me," says Sisto. "The pull of the weave moving across my fingers fills me with energy. When I wake each morning, my first thought is of my work. It is such a joy and an honor to do what I do.

PENNY SISTO
ROOM FULL OF COLOR

In my mother's house there is a room full of color,
a room full of hopes and spirit dreams.
If you look inside you can feel the sadness,
the hoped for gladness toward which it leans.
See the pictures and painted faces,
Demigods dancing and sufferers strife.
Up on the wall a dead deer prances,
a woman lies in pain saying "struggle is my life."
From my mother's thin fingers her inner world is sewn,
and the things she never talks about are publicly
made known.
If you never really knew her, then you would never
really know,
that it is through the cloth and colors
that her deepest feelings show.
And if you ever go there, you will see that it is true,
that in my mother's house there is a room full of color.
 – Jonathan Brackney

51 x 76"

Olmec Mask

Rio Pesquero

"You have a double tongue within your mask..."
Shakespeare, *Love's Labors Lost*, V:ii

A thousand years before the rise of Classical Greece, in the time when King Tutankhamun ruled Egypt, the Olmec civilization arose in the tropical lowlands of Gulf Coast Mexico. Considered the Mother Culture of ancient Mesoamerica, the Olmecs built their cities and temples beginning about 1500 BC. During the ten centuries or more of their dominance, the Olmec kings spread their style far and wide through Mexico and on into Central America, creating Mesoamerica's first International Style. Later Mesoamerican peoples – the Mayas, Teotihuacanos, Toltecs, and even the Aztecs – all looked back to the Olmecs for the origins of civilized life.

Just over a hundred years ago the first traces of the Olmec world began surfacing in and around the swamps of the Mexican State of Veracruz. Colossal portrait heads of stone and miniature jade figurines with mysterious "were-jaguar" features puzzled scholars and collectors. Who created such masterpieces? By the 1940s, archaeologists and art historians grudgingly accepted that the Mayas were not the earliest high civilization in ancient Mexico. Like the later Mayas, the Olmecs excelled in monumental civic architecture, state craft, ceramics and especially the fine arts of painting and sculpture.

The Olmecs were master stonecarvers who used Neolithic technology to produce some of the supreme examples of humanistic sculpture in world art history. Much Olmec art served the needs of the state religion, a belief system deeply rooted in traditions of shamanism.

Unique masks like this example were worn by shaman kings in rituals of transformation, ancestor worship, and deity propitiation. Like all ancient Americans, the Olmecs believed that sacrifice, ritual, dance, and costume could open the pathway to the world of the gods and departed ancestors. Kings controlled access to this realm and wore masks which literally transformed them into ancestor divinities and often grotesque fearsome beings. After their death, masks may have been tied to or placed near royal mummy bundles, preserving forever the image of the king in sacred transformation.

Thirty years ago Mexican villagers happened upon a large cache of stone carvings in and along the banks of the Rio Pesquero, a small river not far from the large Olmec site of La Venta. In the centuries since the Olmecs abandoned the small site of Rio Pesquero, the river's path changed and exposed a series of royal burials and dedicatory offerings. This important discovery revealed not only one of the largest groupings of finely carved stone celts, figurines, and ritual implements, but also many extraordinary masks.

Today, Mesoamerican scholars, museums, and connoisseurs of ancient art prize the masks of Rio Pesquero for their gentle sensitivity and their enlightened humanistic features. Their combination of eminent dynastic power and child-like innocence has a profound and lasting effect on observers.

Collected in the late 1960s, this life-size royal portrait mask expresses the power of the Olmec aesthetic in its blend of strong portraiture and sensitive carving. The mask's soft trance-like gaze, puffy lower eyelids, broad face, fleshy lower lip, and raised upper lip exposing four teeth convey a sense of Olmec individuality. Fine incising describes facial tattooing or yet another mask around the eyes. The U-shaped bracket incised around the mouth relates to images of entrances to the Underworld. The words of the masked king were thought to emanate directly from the realm of the supernatural.

Olmec kings spoke with double tongues within their masks... they uttered not only their own words, but also the wishes of the ancestors and of the very gods themselves.

Middle Formative Period
Rio Pesquero/Veracruz
Pale greenstone
ca. 900-500 BC
7.625H x 7.3125"W

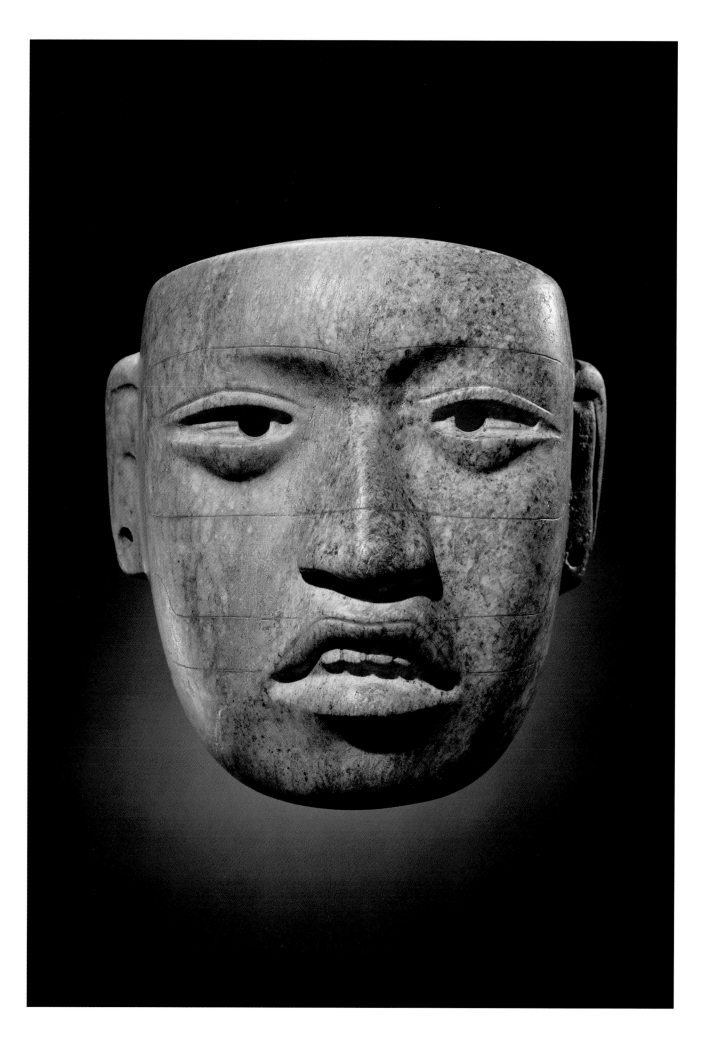

NEW MEXICAN SANTERO

ANTIQUE PENITENTE CRISTO

Hand-adzed wood
gesso, pigment,
and cotton
17 x 21 x 4"
New Mexico, ca. 1800

This unique carving, with its exaggerated loincloth, forearms and feet, is a classic example of those *santero* figures produced outside of northern New Mexico. A note on the reverse side of the cross indicates that the figure, an "antique Penitente *Santo*" was purchased in the Albuquerque area, and that E. Boyd indicated the figure was made in the Casa Colorado area near Tome, outside of Albuquerque. Very few examples from this area remain. The cross, which appears to be original, is of old, hand-adzed wood. The Christ figure is in its

original state, with no repairs or conservation. There are finely painted blood lines on the body; the thumbs are missing on each hand. The overall carving style is unique.

This carving dates from at least the early part of the 19th century to no later than 1825. There are various examples of figures attributable to the Anonymous "Tome Carver," and this piece fits into the stylistic traits of those figures. It is believed this *santero* worked during the same period as the Santero Molleno.

LAGUNA SANTERO

SANTA ROSA DE LIMA RETABLO

Gesso relief
and pigment on board
32.75 x 18.75 x 2"
New Mexico, ca. 1780

This "lovely flower of sanctity," the first canonized saint of the New World and the recognized patroness of the Americas, was born at Lima, Peru, April 30, 1586. She was christened Isabel, but the beauty of her infant face earned for her the title of "Rose." As a child, a thirst for suffering already consumed her heart. Rose was distinguished throughout her life for her austerities and extreme hatred of vanity; her only food seemed to be the Blessed Sacrament. She succumbed to self-inflicted tortures and died at the age of thirty-one.

All of her suffering was offered for conversion of sinners. According to Peruvian legend, Clement X, when asked to canonize her, absolutely refused, exclaiming, "India y santa! asi como llueven rosas!" ("Indian and saint! as likely as that it should rain roses!"; whereupon a miraculous shower of roses began to fall in the Vatican, and did not cease until the Pope acknowledged her canonization. She was named the patron saint of the Americas, the Philippines and the Indies.

This important retablo is the largest gesso relief known to exist from the Laguna Santero.

POTEET VICTORY

TRAILS OF TEARS

Center Panel Study
Oil on linen
84 x 72"

oteet Victory, an artist of Choctaw-Cherokee descent, conveys strong Indian imagery in his critically acclaimed paintings. His large, complex and highly burnished canvases explore the power of symbols, colors, and myths. Victory insists on painting what he knows best and what involves him emotionally. "Painting is dead without emotion," he says.

Victory was born and raised in Idabel, Oklahoma. His earliest memories are of the stories told by the elders, of a forced march of thousands of Native Americans to Oklahoma some 160 years ago. At that time, his family was relocated from their homelands in Mississippi and Tennessee in the thousand-mile journey.

This painting, a section of a fifteen by fifty-foot triptych called "Monumental Trails of Tears Painting," is dedicated as a memorial to the tens of thousands who lost their lives in this tragic migration. When completed, the painting will travel to several states in America and abroad before its permanent installation at the new Sam Noble Oklahoma Museum of Natural History at the University of Oklahoma. "To understand our present we need to know what has gone before," notes Victory.

ALLAN CLARK 1896-1950

HOSTEEN KLAH

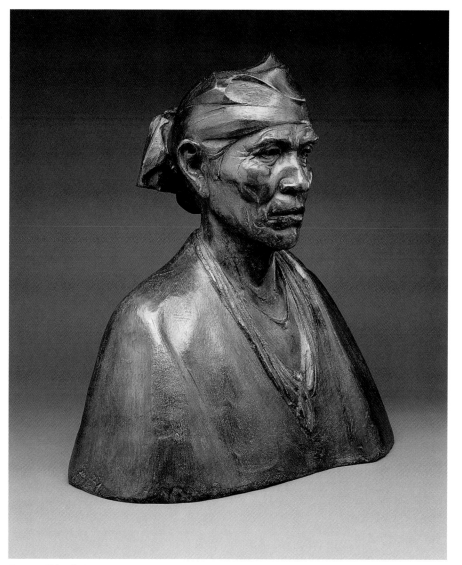

Bronze, Ed. of 40
22 x 20 x 12"

Allan Clark was commissioned by Mary Cabot Wheelwright, patron to the Wheelwright Museum of the American Indian, to sculpt a life-size bust of Hosteen Klah, a famous Navajo medicine man, weaver, and mystic. In 1937 the Wheelwright Museum was dedicated to the memory of Hosteen Klah. He blessed the museum with pollen and prayers before it was opened to the public. Today the museum embraces all Native American cultures, and houses textiles Klah wove which depict sand paintings as well as drawings and some of his ceremonial effects.

When Wheelwright asked him to sit for a portrait bust in 1936, Klah reluctantly agreed. Clark, a sculptor from Santa Fe, made his first model from clay during a three day stay at the Newcomb Trading Post. As Klah's features became clearly recognizable in the model, friends and onlookers became excited. "If that image is not pounded into dust it will take Klah's spirit away."

Subsequently, Clark created a stone bust which was destroyed in an accident. The clay model remains today in private ownership and a limited edition of bronze busts taken from Clark's original have been cast.

GLENNA GOODACRE

THE MILLENNIUM SACAGAWEA DOLLAR

The Millennium Sacagawea Dollar
Obverse Design

Glenna Goodacre is internationally famous for her bronze sculptures. Her most recent triumph is the new Sacagawea Dollar coin that she designed for the U. S. Mint, in honor of the young Indian woman who acted as a guide and interpreter for the Lewis and Clark Expedition. Alone among U. S. coins, the Sacagawea Dollar features a direct look rather than a profile.

A consummate realist, Goodacre depicts ordinary people in ways that point up their extraordinary qualities. The best example is her treatment of children at play – she accords them dignity without diluting their natural freshness. Her pieces, large and small, are in public, corporate, and private collections worldwide. They range from intimate compositions and larger

installations, available in galleries, to the acclaimed Vietnam Women's Memorial in Washington, D.C. Currently in progress is her largest public sculpture to date, the *Irish Famine Memorial* for downtown Philadelphia, with twenty-five life-size figures.

Goodacre, who holds two honorary doctorates, has won countless awards from professional associations, is a Fellow of the National Sculpture Society, and is a member of the National Academy of Design. Despite her remarkable success, the sculptor finds her greatest satisfaction in the work itself. She enjoys the technical challenges, relishes the opportunity to explore many different subjects, and remains closely attuned to the thoughts and feelings of her primary audience of real people.

WILLIAM VINCENT

WILLIAM'S SUNFLOWERS

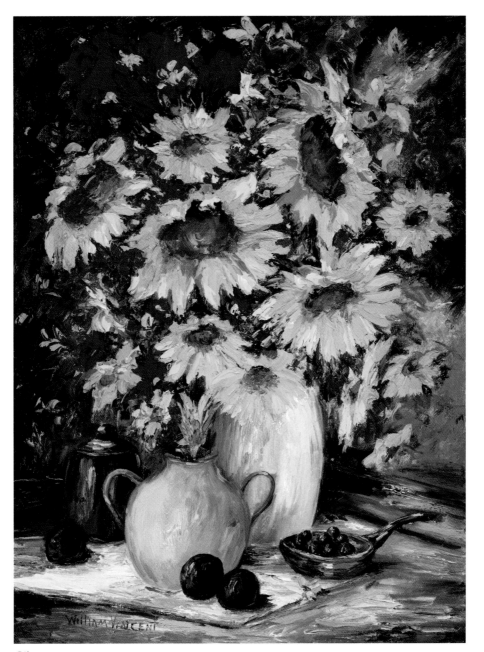

Oil
40 x 30"

William Vincent is known as "the Dean of Canyon Road" in Santa Fe. He arrived forty years ago, met and studied with the legendary early artists, and has kept their spirit alive in his own life and art.

Countless collectors through the years have responded to Vincent's Impressionistic magic. Any subject he chooses seems to glow from within. William Vincent has traveled and painted in more places in the world than any artist in history. He has recorded his impressions of every continent, the seven seas, the great rivers, the jungles, the cities, and the deserts. Always, he returns to New Mexico to paint the winding streets, the snowy winters, and the summer sunflowers in his own enchanted neighborhood.

ISCAYO

AYMARA WOMAN'S CEREMONIAL MANTLE

Bolivian Altiplano
18th Century, alpaca yarns
41 x 58"

For over a thousand years the Aymara Indians have inhabited the high plains, or Altiplano, of southern Peru and Bolivia. They domesticated the alpacas and llamas and learned how to gather the finest of all wools from the wild vicuñas. With these yarns they wove some of the finest and most sophisticated textiles the world has ever seen. Textiles played a dominant role in the social, economic, cultural and religious life of the Aymara. Each style of textile had its own name, specific use, and frequently, a magical power associated with it. The art of weaving symbolized the heart and soul of Aymara culture.

TOM WALDRON

TRACE

.25" Steel
35.5 x 30 x 20"

om Waldron has been transporting, slicing, welding, grinding, and manipulating massive sheets of salvaged steel in his studio in Albuquerque, New Mexico, for two decades. The reward for this arduous toil is contained in each gemlike sculpture. "Usually I conceive a sculpture as pure geometric form," Waldron explains, "but as it takes shape, it starts to deviate from this conception as the material contributes its own tendencies and possibilities." Waldron's sculpture appears to have been carved from solid mass, the curves molded and the angles cut, but is actually fabricated from quarter inch steel sheets.

Tom Waldron attended Notre Dame, received a B.A. in architecture from the University of Minnesota, and studied art at the University of New Mexico from 1977 to 1979. Named as an artist to watch in the 90s by Artnews magazine, he has had more than a dozen solo exhibitions since 1984.

ELMER SCHOOLEY

VARIATIONS ON A THEME BY TED 1

Oil on canvas
42 x 48″

Elmer Schooley is one of the country's most respected painters. His paintings are well represented in prominent collections and museums, including the Museum of Modern Art in New York, the New Mexico Museum of Fine Arts in Santa Fe and the Dallas Museum of Art.

Schooley taught at New Mexico Highlands University in Las Vegas, New Mexico, for thirty years, acquiring a formidable reputation in the process. He retired to Roswell, where he now devotes his time to creating his large-format (approximately 80 x 90") oil paintings, spending several hundred hours on each piece and completing one or two pieces a year. Schooley starts a painting "with detail and end(s) with form," using all manner of tools to apply paint to canvas in order to achieve the bird's-eye perspective for which he is so well known. At age 83, says Schooley, "seeing is my greatest pleasure. Painting is my response to seeing."

ENRICO EMBROLI

DIALOGUE

Mixed media/oil
60 x 88"

Enrico Embroli's paintings are woven together by the thread of human communication and abstract dialogue. His work reveals an artist who is bold enough to unmask and render intimate and imagined conversations that exist between human beings, between the worlds of the physical and the spiritual, and in subconscious thought. Embroli's visual script creates a meeting ground to stimulate thoughts and dialogue, and invites the viewer to interpret his abstract expression of the emotional, sexual, spiritual and physical nature of humanity.

The fascinating textural surface of Embroli's paintings has been a signature of his visual vocabulary for the duration of his art career. He confidently handles paint with a sculptural convergence, adding yet another exciting dimension of volume and energy to his work.

Enrico Embroli is an internationally exhibited and recognized painter and sculptor. His work has been selected for distinguished corporate and private collections throughout the world.

SHERRIE McGRAW

NUDO NELLO STUDIO

Oil on canvas
10 x 16"

Sherrie McGraw, at the unlikely age of four years, in the unlikely town of Ponca City, Oklahoma, made a resolution to become an artist. This early resolve went largely unnoticed, except by her mother, until it found fruition – in New York City's world famous Art Students League.

McGraw's previous training focused only on technique and left her dry, wanting, and questioning her desire to paint at all. At the League, she found David A. Leffel, an instructor whose work possessed the qualities she intuitively desired – beauty and intelligence. Her early passion reignited, she resumed her journey along the almost abandoned path of realism. Unquestionably, she was captivated and inspired by contemporary followers of the *chiaroscuro* school of thought such as Walter Murch, Hovsep Pushman, and Priscilla Roberts.

Although the appearance of McGraw's work is objective, realistic, her concerns transcend subject matter. The elements that she juggles, hard and soft edges, color relationships, values and shapes and the sensuality of paint surface, though seemingly real, are highly abstract.

McGraw states: "Painting records an artist's struggle for understanding. In practical terms, prejudices and assumptions prevent proper seeing. Painting allows a journey to unfold daily as mental or technical impediments are met, and laid to rest. Intelligence comes when one discards the false."

An enthusiastic teacher, McGraw later taught at the Art Students League as well as at workshops nationwide. Her paintings and drawings have been shown in many museums and reside in prominent art collections both here in in Europe.

CAMEROON RICE BASKET

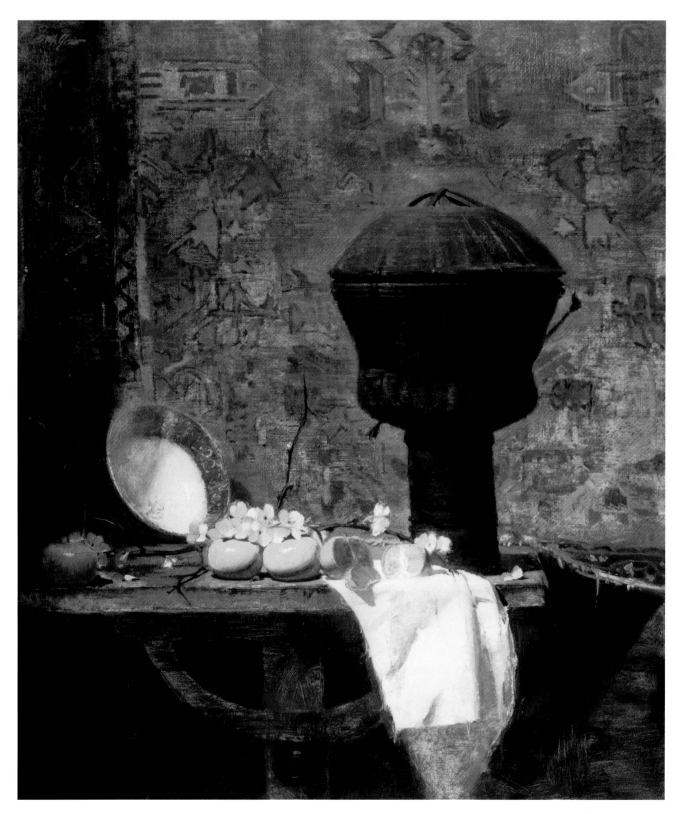

Oil on canvas
28 x 23″

JEAN-CLAUDE GAUGY

BOUQUET CLASSIQUE

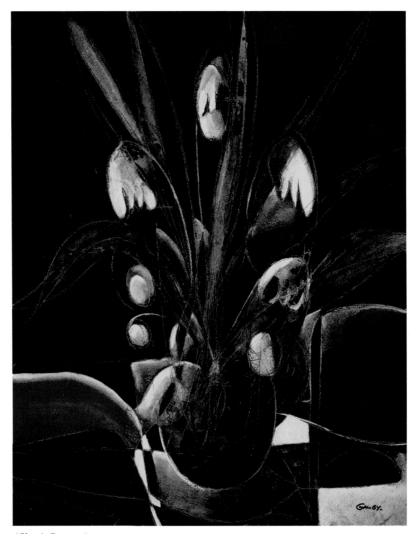

(Classic Bouquet)
Mixed media on carved wood
24 x 18"

Jean-Claude Gaugy is an artist on a quest; a restless journey of quizzical discovery where the value of questions far outweighs the transitory solace of answers. Born in the rugged Jura region of France, he entered a 400 year family artistic tradition that began for him at age four with weekly drawing critiques by his grandfather. Early immersion into centuries-old values formed his firm belief that communication of transcendent truths and craftsmanship are the basis and essential obligations of artistry, through which self-expression must always be filtered. Subsequent studies, primarily as a sculptor, included Beaux Arts in Paris, the School of Sculpture in Moscow, School of Design in Rome, and apprenticeship with Henry Moore. Salvador Dali sponsored his first Paris exhibition.

Gaugy's signature medium is paintings carved into wood with no preliminary drawings whatsoever. Intense and permanent lines combine with subtle painting to convey powerful emotions with an arresting delicacy and masterful tension. His focused skill has led to his designation as the master of Linear Expressionism. Jean-Claude Gaugy exhibits worldwide and is in major museum collections.

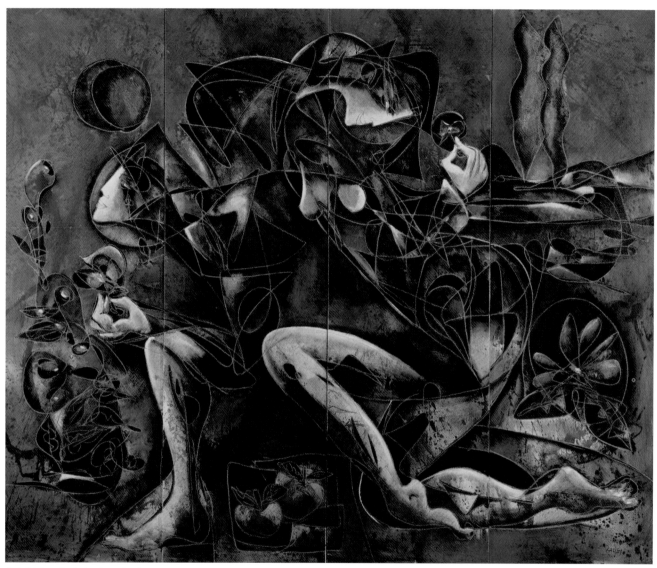

(We Make a Path for Ourselves)
Mixed media on carved wood
Four panel screen, 1999
80 x 96"

CAROL ANTHONY

HOMAGE TO ELAINE: VESTIGE REMEMBERED

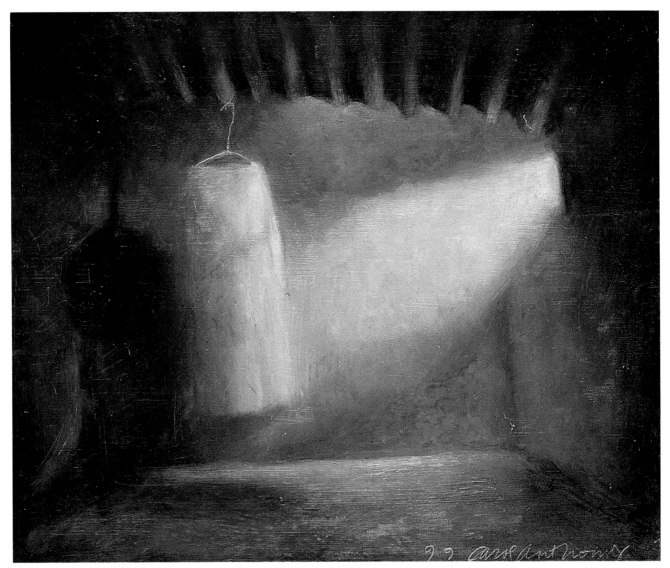

Oil crayon on gessoed panel
19 x 20"

Carol Anthony is an acclaimed New Mexico artist whose primary media are craypas (oil crayon) and enamel on gessoed panel, and the monotype. She sands and gessoes her panels multiple times and then begins to add layers of oil crayon. What makes Anthony's work unique is her extremely skillful and carefully modulated utilization of her materials. This creates an atmospheric light quality that evokes a sense of mystery and quiet melancholy combined with a classic, Rembrandt-like glow.

Carol Anthony's work is represented in the permanent collections of the Smithsonian Institution, the Hirschhorn Museum and Sculpture Garden and the Carnegie Institute, among others, as well as numerous major corporate and private collections.

LANFORD MONROE

IN MOTHER'S FOOTSTEPS

Oil on canvas
24 x 36"

Lanford Monroe is a leading wildlife artist whose parents, illustrator C.E. Monroe and portraitist Betty Monroe, along with neighbors Bob Kuhn and John Clymer, introduced her to art. She completed her first commission at age six and later was awarded a Hallmark Scholarship in Fine Art, attending the well-known Ringling School of Art in Florida. She is best known for atmospherically moody North American and European landscapes that include wildlife as one would see it in nature. Monroe also creates paintings and sculptures of horses.

Her numerous honors include the Society of Animal Artists Award of Excellence, the American Academy of Equine Arts Popular Prize and landscape awards, the Grand Teton Natural History Association Award, and three awards from the Salmagundi Club in painting and sculpture. For the Arts in the Parks competition, she has received the USArt Magazine award, the Yellowstone National Park Purchase Award, and the Buyers' Choice Award. Monroe has been featured in two books, *From the Wild* and *Leading the West*, and in many periodicals. Art of the West listed her in 1999 as one of the leading artists of the millennium.

Lanford Monroe's works are included in the public and corporate collections of the National Museum of Wildlife Art, the Leigh Yawkey Woodson Museum of Art, the Massachusetts Audubon Society, Hearst Corporation, P.A.B. Widener, Sports Afield, Southern Bell, South Central Bell, the Huntsville, Alabama Museum of Art, and the Hiram Blauvelt Museum in New Jersey.

E. MARTIN HENNINGS 1886-1956

CROSSING THE STREAM

Oil on board
12 x 14"

E Martin Hennings was born in Pennsgrove, New Jersey, the son of a skilled craftsman. His family soon moved to Chicago where he enrolled at the Art Institute, graduating with honors after five years. He then traveled to Munich to study with leading teachers Franz von Stuck and Angelo Jank, remaining in Germany until the outbreak of World War I.

Hennings returned to Chicago and was soon commissioned by noted art patron, Carter Harrison, to paint at Taos. Though he maintained a part-time studio in Chicago until the Depression, Hennings made Taos and its many attractions the subject of his life's work, settling there permanently in 1921.

By 1922, Hennings was gaining recognition and winning many prestigious awards, including the Art Institute of Chicago's Clyde M. Carr Memorial Prize and the Martin B. Cahn Prize. The National Academy of Design awarded him the Ranger Fund Purchase Prize in 1926. A one-man show at Marshall Field & Co. in 1925 led to his meeting of and subsequent marriage to Helen Otte. The couple returned to Taos, where Hennings enjoyed a successful career until his death.

E. Martin Hennings was an incomparable draftsman, which allowed him the foundation on which to create his lyrical compositions. He is most noted for his paintings of Indians placed against the incredible background of the high desert landscape. Often infused with dappled sunlight, his paintings are like tapestries; rich colors and stylized forms create peaceful and luminous images of life in Taos.

O.E. BERNINGHAUS 1874-1952

HORSES IN TAOS

Oil
24 x 30"

Oscar E. Berninghaus began his career in his native St. Louis as a commercial lithographer. In 1899, as a reward for his hard work in taking night classes at Washington University and at the St. Louis School of Fine Arts, he was given a month's paid vacation and provided with free passage to the West by the Denver and Rio Grande Railroad. While visiting Taos, Berninghaus met Bert Phillips, who became a life-long friend, and was inspired to join the new Taos artist colony.

Berninghaus established a seasonal rhythm based on his family's needs, spending winters in St. Louis pursuing a successful career as a commercial artist and summers in Taos painting the Native Americans, their horses, and the landscape. These candid paintings of

Taos earned him great respect among the other artists. Though residing in St. Louis, he became a founding member of the Taos Society of Artists in 1915 and sent his paintings on tour with their traveling exhibitions. Successful accounts, especially Anheuser-Busch, allowed him to settle in Taos permanently in 1925.

Berninghaus received the 1924 Ranger Fund Prize and the 1926 Second Altman Prize from the National Academy of Design. He also belonged to the National Society of Mural Painters and the Salmagundi Club. Berninghaus' paintings are often set in spring and fall, when the amazing colors of New Mexico are at their strongest. His beautifully rendered paintings offer a vision of Taos unburdened by romantic aspirations.

LEON GASPARD 1882-1964

RUSSIAN VILLAGE

Vibrant, rich in culture, and multilayered. Thus was the Russia into which Leon Gaspard was born in the late nineteenth century, and these are the words that would come to describe his art as well.

Gaspard was born on March 2, 1882, in Vitebsk, a town west of Moscow on the Dvina River. While his musically-gifted mother tried to coax him to study the violin, Leon was seduced instead by the splendidly dressed Kirghiz tribesmen he encountered when accompanying his father on fur and rug trading expeditions into the Siberian steppes. Gaspard began to sketch on these trips; he was entranced by the colors, people, and activities swirling around him. His early affinity for these tribes and their culture, and his exposure to Byzantine art and architecture, as well as Russia's overwhelming sense of nationalism at the time, would forever influence his work.

When he was fifteen, Gaspard apprenticed with a contractor who painted Byzantine-style murals of saints in local churches. Soon thereafter, he enrolled in a local art class. Gaspard had his first taste of success when he was just seventeen and left home to study art in Paris; it was there that the founder of New York's Pratt Institute bought thirty-five of his sketches. In 1909, Gaspard married an American woman whom he followed to New York seven years later, after he was injured in the French Aviation Corps early in World War I. With heightened public interest in the war effort, Gaspard's war sketches, exhibited at the Rhinehart Gallery, garnered much attention.

In 1918, in search of a warmer climate, Gaspard and his wife journeyed to Taos, New Mexico, a town which surprised him in its similarities to his beloved Russia. Despite his uncanny, innate familiarity with his new surroundings, Gaspard was a foreigner and not received well by the community. Rebuffed by the Taos Society of Artists, he refused to ever show his work in Taos. For the next forty years, he opted instead to ship his paintings to galleries in New York, Detroit, and Los Angeles.

Gaspard still became a permanent resident of Taos, but, beginning in 1921, he spent much of his time traveling through remote regions of Asia and the Orient. Usually journeying by horse or camel, Gaspard used lightweight, easily carried rolls of coarse Chinese silk for his canvases. Examples of this "sketching silk" can still be seen under many of Gaspard's layered palettes.

In New Mexico, the Asian facial features of the Taos Pueblo Indians, the Hopis, and the Navajos, as well as their brilliantly-colored clothing, silver and turquoise jewelry, processions, and fiestas echoed Gaspard's Asian subjects. His colorfully embroidered paintings of the Native Americans in New Mexico comprise some of his strongest work.

Perhaps an unconscious ode to his mother's passion for music, Gaspard seems to have painted "sound" into his canvases. Mongolian ponies snort and stomp in the cold. One can hear the rumble of sleighs and the grating of the chains that drag them. From his colorful canvases come the sounds of fiddlers fiddling and children laughing. And the omnipresent bells – the tinkle and ring of them embedded in sleigh trappings and strung on saddle leather; the chime and boom of them from the onion-domed Orthodox churches.

Clearly unique among painters ever to live in New Mexico, Leon Gaspard captured the souls and sensibilities of some of the most colorful "tribes" in the world. The "vibrant, rich, and multilayered" tapestries he so masterfully painted preserved these peoples and their spirit for all time.

Oil on canvas/mounted on board, ca. 1912
12.5 x 9"

MARSDEN HARTLEY 1877-1943

STILL LIFE

Oil on board, ca. 1929
12.75 x 21"

Marsden Hartley lived and worked in New Mexico in 1918 and 1919, yet he continued for years to work with the imagery he discovered during his stay in Taos. He made pastel drawings of the neighboring mountains, arroyos, and desert vistas, and also wrote a series of articles emphasizing the importance of painting the American land with a new realism, based on the principles of modern art but directed toward American subject. Hartley became interested in New Mexican *santos*, ceremonial images made by the local descendants of Spanish colonists. Even then, these devotional objects were recognized as an important form of American folk art. The artist began a series of still-life *santo* paintings that were neither naturalistic nor abstract, but were flat and two-dimensional like the traditional folk art itself.

After leaving New Mexico, Hartley completed a series of New Mexico Recollections, a theme to which he returned several times. He painted naturalistic representations of the desert and distant mountains, and explored the relationship between the man-made adobe structures of New Mexico and the sinuous earth and tree forms silhouetted against the eternal backdrop of mountains and clouds. Later, he included singular forms such as a house or cemetery.

Marsden Hartley had many one-artist exhibitions in Alfred Stieglitz's galleries and, with other American modernists, participated in many group exhibitions including all the Whitney Museum Biennials that were held in his lifetime. Like many other artists who never realized commercial success while they were alive and able to enjoy it, Hartley had a fine art education and dedicated his life to the pursuit of his artistic vision. Today, his work has assumed its rightful place in art history, and enjoys public recognition and acclaim by collectors and museums.

ANDREW M. DASBURG 1887-1979

AUTUMN – RANCHOS DE TAOS

Oil on canvas, 1930
18.5 x 30.25"

A ndrew Dasburg grew up in New York City, where he attended the Art Students League. Later, he traveled to Paris and discovered the work of Paul Cézanne, who became his major influence. Returning to New York, he participated in the 1913 Armory Show which broke new ground in American art. In 1918, his good friend Mabel Dodge Luhan invited him to Taos, New Mexico, where the stunning environment captured his imagination and solidified his style. He painted mostly landscapes, still-life compositions, and a few portraits, and gradually his work returned to the abstracted style of his younger days.

After a bout with ill health, Dasburg recovered to enter his most productive phase. Encouraged by the sale of his works to the Metropolitan Museum of Art and the Whitney Museum in New York City, he began experimenting with a flattened and condensed sense of space.

He often used a sharpened charcoal stick to emphasize a linear break between two colors or two forms. He worked with pastels and, at the age of eighty-eight, began a series of lithographs, continuing with another series the following year. He died peacefully at home in Taos three years later.

As an American artist, Andrew Dasburg is recognized as one who heroically carried on the battle for modernism in New York in the early years of this century. As a New Mexico artist, his influence is even more pervasive. His paintings, pastels, drawings, and lithographs remain fresh and vital today. He produced a radiant body of work that captures the landscape in clean lines and shapes, revealing the underlying geometry of mountain, plain, and adobe architecture. Generations of artists have carried forward his deep structural understanding, inspired by Cézanne but finally and unquestionably his own.

EMIL BISTTRAM 1895-1976

FLOWER FORMS

Oil on canvas, 1934-35
36 x 32"

E mil Bisttram left his native Hungary at the age of seven to move to New York. He studied art at the National Academy of Design, Cooper Union and the Art Students League. In 1931 he studied mural painting in Mexico with Diego Rivera on a Guggenheim Fellowship.

Bisttram moved to Taos, New Mexico, in 1932. He started his own gallery and art school and, in 1938, became a founding member of the important Transcendental Painting Group with Raymond Jonson, William Lumpkins, Alfred Morang and others. In the ensuing years Bisttram worked in several styles, both realistic

and nonobjective, and continued to create abstractions based on Jay Hambidge's Dynamic Symmetry theory.

For many years Emil Bisttram continued his explorations with abstracting natural forms, eventually reaching total nonobjectivity. The study for *Flower Forms*, which is in the permanent collection of the Roswell Museum and Art Center, is imaged in Sharyn Udall's book *Modernist Painting* in New Mexico 1913-1935. The painting is very reminiscent, both in style and subject matter, of an early work by Charles Sheeler, also titled *Flower Forms*, dated 1917-19, now in the collection of the Terra Museum of American Art in Chicago.

Gene Kloss, N.A. 1903-1996

PENITENTE EASTER

Etching, drypoint, aquatint, 1979
11 x 14"

Gene Kloss began her career in her home state of California, but was deeply moved by a honeymoon visit to Taos in the twenties. This began her fascination with New Mexico, which lasted over seven decades. During this time she was able to express her reverence, love and awe for the landscape, the varied rituals of its diverse cultures, and the charm of the villages through her impeccable skills as a master printmaker and painter. Her desire for historical accuracy, combined with meticulous attention to detail, compelled her to personally pull each and every print of every edition of her 631 known etchings. Her artistic and personal objective was to record her impressions of things she considered beautiful and important.

Her work garnered national and international acclaim, and was acquired for the permanent collections of the Carnegie Institute, the Smithsonian, the Metropolitan Museum of Art, and the museums of Tokyo and the Hague, to name a few. She was an Academician of the National Academy of Design and was awarded prestigious honors throughout her lifetime.

THÉRÈSE EVANGEL

INVITATION

Oil
40 x 48"

Thérèse Evangel's architectural landscapes are saturated with the human presence. She has spent a lifetime observing the people and the architecture of her native Southwest and learning its almost Renaissance lights and shadows by heart. Evangel is interested in the way the built environment speaks of the people who have created it for themselves. The viewer's eye is led into the background by means of a path or other compositional device, but then the path

ends and the imagination must take over. Evangel's paintings have a gracious and refined atmosphere, yet just beneath it lurks an edge of intensity, a sure knowledge that the peaceful streetscape of today may be the nostalgic touchstone of a less benign tomorrow.

Thérèse Evangel works with oil, watercolor, and pastel. Her paintings have been shown throughout the United States, and are included in many private and corporate collections.

ARLENE LaDELL HAYES

CROWS SHOULD KNOW BETTER III

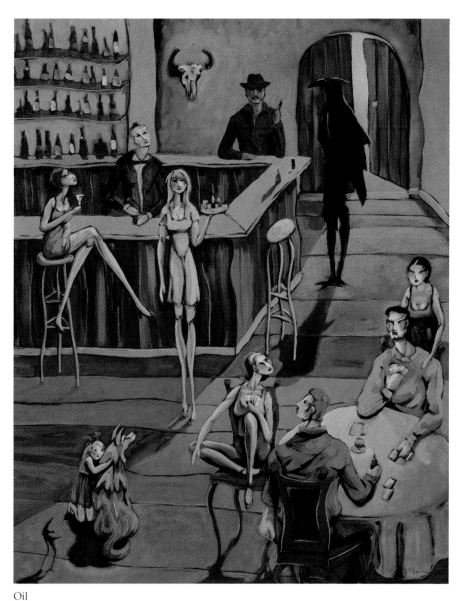

Oil
30 x 24"

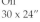rlene LaDell Hayes was born and raised in the Texas panhandle. The sparse beauty of the region stimulated her artistic imagination from an early age. She began her career as an artist in Santa Fe, New Mexico, producing historically accurate bronze sculptures with a focus on Native American themes. After mastering the human figure in three dimensions, Hayes turned to painting and began to abstract the form. Her multiple styles, variety of subject matter, and intensely hued canvases display universal influences. The work is strong in line, merging the conscious and the subconscious, and drawing on both Eastern and Western tradition. Her calligraphic brushwork accentuates the dreamlike forms.

Arlene LaDell Hayes is currently painting expressionistic barrooms, powder rooms, and other interiors she has encountered in her travels. Strikingly different from her previous works, these paintings are kaleidoscopes of color and form that entice the viewer to take part in the festivities.

R.C. GORMAN

YOUNG DOVE

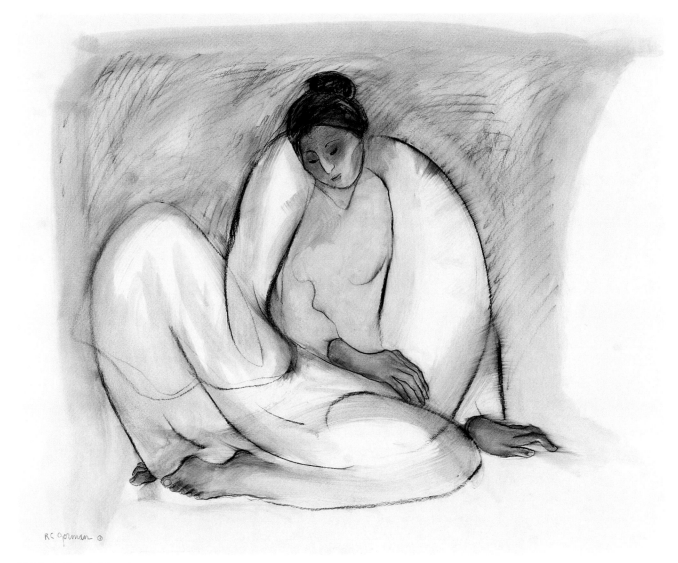

Original oil pastel drawing
48.5 x 41" framed

R C. Gorman's name is indivisibly linked with Contemporary American Indian Art. Perhaps there is someone, somewhere, who has never heard of him, but that is doubtful. His solid, graceful drawings, paintings, and sculptures of Navajo women are familiar to all.

Gorman was born and raised on the Navajo Reservation in northern Arizona. His ancestors were Navajo weavers, sand painters, chanters, and jewelers. As a child he herded sheep with his grandmother and learned to watch the natural world very closely and to see the beauty all around him. Like his forbears, he drew on the walls of Canyon de Chelly. Later, he studied at the university in Mexico City, where he was particularly drawn to the work of the Mexican mural painters.

R. C. Gorman's formal education was minimal, but his gift is great. Today his work hangs in the Metropolitan, the Heard Museum, the Smithsonian, the Philbrook, and the Museum of Fine Arts in Santa Fe, in addition to many other international collections, both public and private.

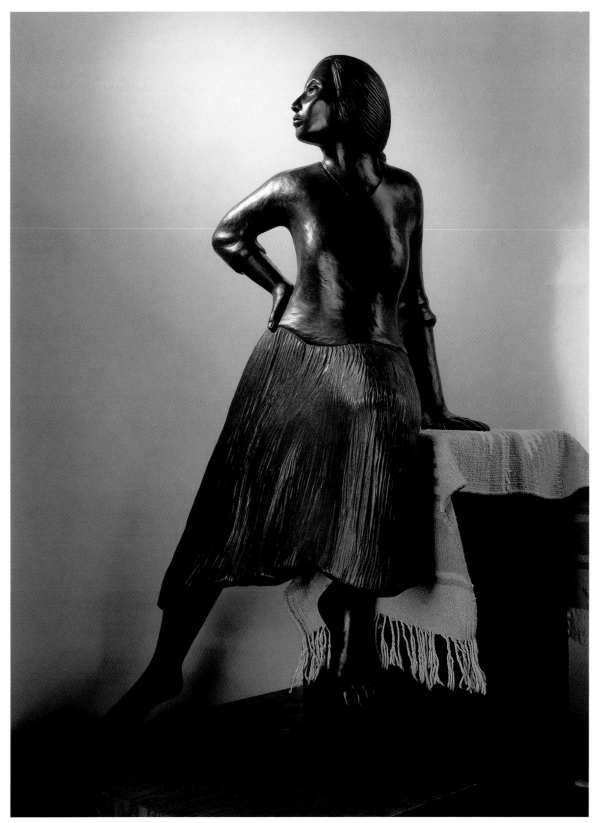

Bronze
51″H

BELLA COOLA

FRONTLET

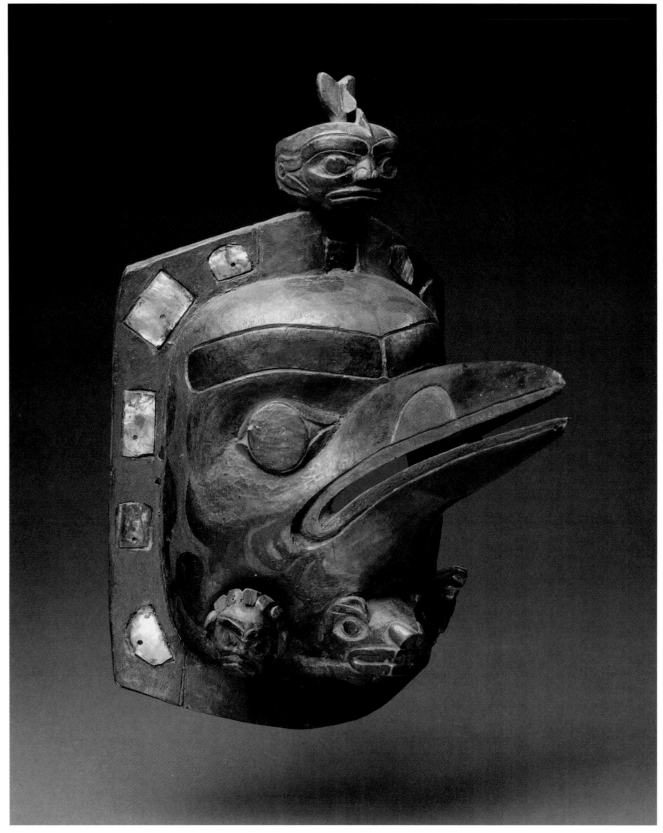

ca. 1870

CROW WAR SHIRT

ca. 1860

This is an excellent example of a Northern Plains Crow poncho-style war shirt. It was constructed in 1860 of native tanned Bighorn sheep hide, and accented with ermine skin suspensions and beadwork. The beadwork is laid out in blocks of red and green bands upon a blue background. These bands are indicative of the wearer's successful battle exploits. Crow war leaders and pipe holders would have earned the right to don such an impressive garment.

JD CHALLENGER

GOING HOME

JD Challenger is unique among non-Indian painters of Indian subjects in that he avoided that imagery for many years, solely out of respect for the sensibilities of his lifelong friends who were Native Americans. He was already a successful landscape painter, with many years of struggle and artistic development behind him, when he was overwhelmed by an inspiration to explore the very soul of the Indian experience by means of the vivid portraits for which he has become universally recognized. Before he ever created his first canvas, however, he made a journey to confer with the elders and medicine men he knew best. They recognized his sincerity and gave him their blessing, without which he could not have proceeded.

Today, Challenger is a major figure in Southwestern art. His first book *Ghost Dancing*, describes the symbolism and ceremonies that continue to inspire him. His details are rich and authentic; the gaze of his figures is unswerving, conveying a tribal spirit threatened but not broken by modern life. JD Challenger's sure-handed technique and thoughtful attention to content produce unforgettable statements of courage and freedom. His work and its emotional subtext have a profound impact on all those who see it.

Acrylic on canvas
72 x 36"
Courtesy Sierzegen Collection

MIGUEL MARTINEZ

TIME

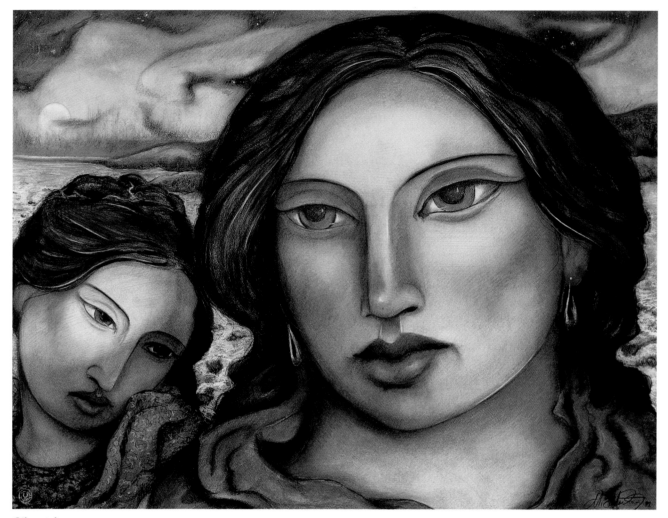

Oil pastel
30 x 40"

Miguel Martinez is widely known for his iconic portraits of women. He began with the faces that were familiar to him in his home town of Taos, New Mexico, where his Spanish Colonial ancestors arrived long before the first artists made it a legendary art colony. Martinez devoted many years to the development of his craft, focusing on the technical aspects as well as the history of art. He was particularly drawn to the work of Picasso, Modigliani, Tamayo, and Rivera, learning much from their content but forging his own instantly recognizable style.

As Martinez matured and traveled about the world, and as his art progressed, the faces took on a more timeless cast. They have become less specific to individual personalities and more concerned with the underlying humanity of the powerful female figures of the world. Each of Miguel Martinez' paintings and fine prints evolves slowly and deliberately, as he works back and forth to bring the emerging image to life. The completed work of art is quiet and lovely, yet is saturated with an emotional intensity that registers each eloquent face indelibly on the viewer's eye and heart.

SHELBEE MARES

Mixed media
63 x 75"

GARDEN OF SECRETS

Shelbee Mares visited New Mexico in the 1980s, then returned to the coast of Maine to study art. Inspired by the Southwest, she fused the two cultures together in her work. Now residing in Taos, she is widely collected, and recently received a People's Choice award at the city's art festival. Like the French Impressionists Monet and Renoir, Mares uses an abstract approach to create the illusion of forms bathed in light and of a transparent atmosphere with delicate nuances found only by a deliberate search.

JACOBO DE LA SERNA

Ceramic vessels

Jacobo de la Serna, a native of northern New Mexico, is a noted ceramist as well as a *santero*, or maker of altarpieces in the Spanish Colonial tradition. De la Serna, a favorite exhibitor at the annual Spanish Market in Santa Fe, is known for both his innovative and his traditional approaches. He works with the native micaceous clay that is typically used for utilitarian cooking and storage vessels as well as nonmicaceous clay and colored slips found in early Hispanic settlements to create new forms that seem to arise from the very earth from which they are made.

SARAH BIENVENU

CLOUDS BEHIND THE MESA

Watercolor
19.5 x 28.75"

MARTHA KEATS GALLERY, SANTA FE

HAROLD O'CONNOR

Harold O'Connor works with the same kinds of themes contemporary sculptors use in their large pieces. His exquisite wearable artworks have equal impact, combining a postmodernist consciousness with ancient, evocative subjects and organic designs. Graduate work in Finland, Germany, Denmark, and Austria solidified his conceptual bent and sharpened his technical skills to a very high degree. Harold O'Connor's work is in the permanent collections of Goldsmiths Hall in London and the Renwick Gallery of the Smithsonian Institution.

Sterling silver
24 and 18 karat gold

BRUCE LAFOUNTAIN

WIND OF TRUTH

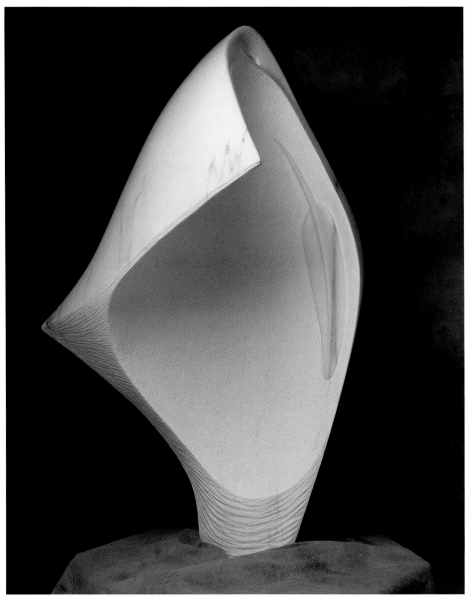

Colorado marble – available in limited edition bronze
48H x 31"D

Bruce La Fountain arrived in Santa Fe twenty years ago to visit relatives and friends who were major artists of that era, and found his life's work as a sculptor. "They opened my eyes and spirit to create art," he says. "I feel very lucky." He has won awards at Santa Fe's annual Indian Market, a grand prize from the Smithsonian's Museum of the American Indian, and major commissions from Teleglobe Communications of Canada and the Eiteljorg Museum.

La Fountain, who is of Chippewa and French ancestry, draws his inspiration from the mundane complexities of everyday life. "When I work, I think about these experiences," he says. "Sculpture takes them all and puts them in a medium that I can look at and see the truth." He chooses the hardest stones to work with, finding that the deliberate pace enables him to meet the challenge of returning to the original state of simplicity that his ideas demand.

DONNA CLAIR

LAST LIGHT AT TRUCHAS

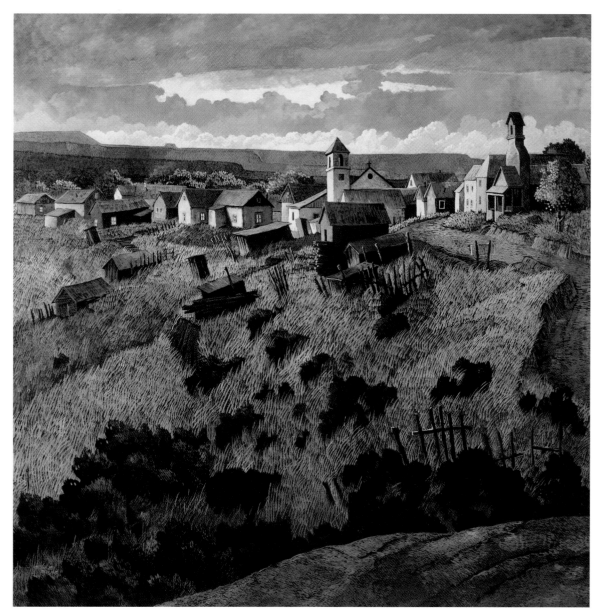

Giclée on paper
30 x 30″

Donna Clair's crisp staccato brushwork and sharply defined colors convey the sheer electricity of northern New Mexico. Her sense of structure is evident in her solid, peaceful paintings of this place she loves and calls home.

As a girl, Clair spent a lot of time in front of her favorite paintings at the Art Institute in Chicago, marveling at the clarity of the French Impressionists.

She moved to the Southwest as a young woman and immediately fell under its enchantment. Her unique viewpoint is based on her early passion for the art of the masters, brought into focus by the lyrical surroundings of her adult life. Donna Clair's work resonates with authenticity, not only of painting technique and style, but of the land itself.

WAYNE MIKOSZ AND RIHA ROTHBERG

SPONTANEOUS UPRISING

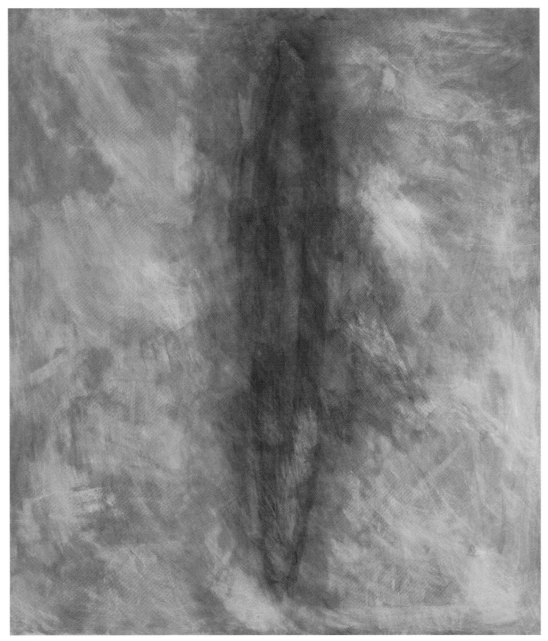

Acrylic on canvas
68 x 60″

Wayne Mikosz and Riha Rothberg put art before ego to create the rich and vibrant paintings they have been collaborating on since 1995. The pair paints side by side as they explore a common language of mark-making, color and rhythm. The work evokes memories and sensations as it speaks to emotions. The viewer-as-participant experiences his own connection to shared process, while the coherent unity achieved diminishes the importance of the question: which artist made what stroke?

The Placitas studio of Mikosz and Rothberg is nestled in the northern foothills of the Sandias. Their works are collected internationally.

INGER JIRBY

STARS, MOON & MESA

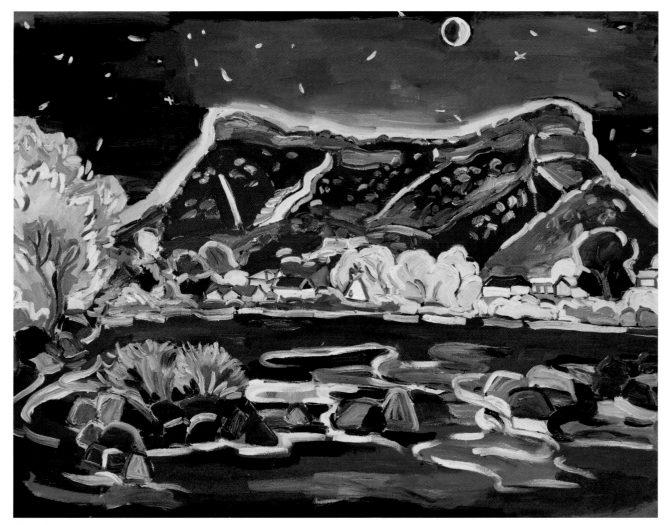

Oil on linen
38 x 50"

nger Jirby is a free and powerful painter whose distinctive style has made her work instantly recognizable. Collectors all over the world respond to her intense colors, dramatic compositions, and the joyfulness of her paintings. Her forms are built on cubism. She is a colorist and color is an important part of her expression. Inger Jirby's vision belongs to her alone.

Jirby has been an artist all her life, beginning with her childhood in Swedish Lapland above the Arctic Circle. The area was a magnet for artists who came to paint the extraordinary colors and the clear skies in the fall.

As an adult, Jirby studied in Greece, Venice, Paris, and New York before settling into Santa Fe almost two decades ago. She subsequently built a studio in the village of Pilar on the Rio Grande Gorge. A few years ago she moved her base of operations to Taos.

Inger Jirby's art is exuberant and lively, a dance of paint and emotion. "When I paint, I feel a part of nature. Before beginning to paint I am inspired and will have a vision of color and composition. But when I start to paint I get in touch with my intuitive knowledge and my creativity."

JOHN NIETO

FEATHER DANCER

Acrylic
60 x 48"

John Nieto, a celebrated and influential interpreter of his native Southwest, is one of the best known contemporary artists in the United States. His dramatic, vibrantly colored compositions have been exhibited throughout the United States and in Europe, Japan, Latin America and Africa. His paintings hang in the permanent collections of the New Mexico Museum of Fine Arts in Santa Fe, the Marine Corps Museum in Washington, DC, the Heard Museum in Phoenix, and the National Museum of Wildlife Art in Jackson Hole, Wyoming.

JOHN AXTON

OTHER SHORES

Oil
48 x 60"

ohn Axton's haunting minimalist paintings are famous for their mystery, silence and deep calm. There is a timeless space in each canvas, inviting the viewer's own thoughts to expand. The visible world, here, is merely a veil for the unseen reality.

Axton's subjects have changed through the years, but the abiding tranquillity of his ongoing concept has earned him many honors. He was awarded an Outstanding Alumni Achievement Award by his alma mater, Southern Illinois University, in 1988. In 1996, the editors of Southwest Art Magazine selected his work for the prestigious traveling museum exhibition *Covering the West*. Among the other museums that have exhibited Axton's work are the Albright-Knox in Buffalo, New York, the Philadelphia Museum, the Denver Art Museum, the National Cowboy Hall of Fame in Oklahoma City, and the Autry Museum of Western Heritage in Los Angeles. John Axton is represented in the permanent collections of the Pratt Museum in New York and the Museum of Fine Arts in Santa Fe.

ALBERT HANDELL

RANCHO ENCANTADO ROAD

Pastel
14 x 15"

lbert Handell brings the magic of the Southwest to life. Adobe walls glow from within like embers. Mud puddles light up like fiery mirrors in the late afternoon sun. Billowing clouds turn from pale gold to deep red as evening approaches.

Handell was classically educated at the Art Students League in his native New York City, followed by four years of study in Paris. Already an artist of national stature when he moved to Santa Fe in the 1980s, he is

a longtime member of the Hall of Fame of the prestigious Pastel Society of America, one of only a handful of artists thus honored. Albert Handell's paintings hang in the permanent collections of the Art Students League of New York, the Brooklyn Museum of Art, the Syracuse Museum of Art, the Schenectady Museum of Art, the Utah Museum of Art, and the Southern Alleghenies Museum of Art in Pennsylvania.

VERYL GOODNIGHT

THE DAY THE WALL CAME DOWN

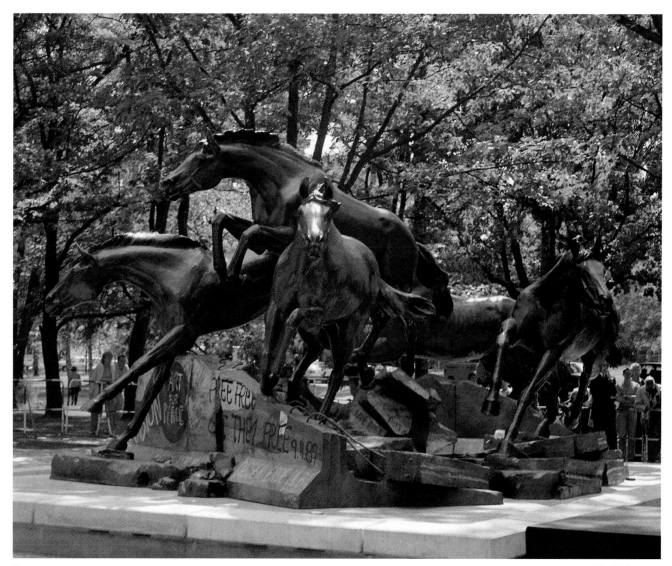

Bronze
18W x 30L x 12'H

Allied Museum
Berlin, Germany

Veryl Goodnight is an internationally recognized sculptor of representational Western and equine subjects, and is especially known for her monument-size work. A descendent of pioneer Texas rancher Charlie Goodnight, she lives and works surrounded by horses in an adobe studio north of Santa Fe.

In *The Day The Wall Came Down*, Goodnight used horses jumping over the fallen Berlin Wall to represent freedom. The "sister" castings of this seven ton monument are located at the George Bush Presidential Library in Texas and the Allied Museum in Berlin, Germany. The United States Air Force flew the German casting to Berlin on the 50th anniversary of the Berlin Airlift. President George Bush unveiled the sculpture on July 2, 1998 as a gift from the American people. *The Day The Wall Came Down* is the artistic symbol representing the end of the Cold War. At the George Bush Presidential Library in November 1999, the Central Intelligence Agency placed a wreath at the base of the sculpture, remembering those who died fighting the Cold War. It reads, "In memory of those who died so that others might be free."

TOM KIRBY

INVISIBLE WIND

Tom Kirby's work evokes themes of transcendence and aesthetic romanticism displaying his love of nature and of contemplation.

Mixed media on canvas
60 x 92" Diptych

PASCAL

OCEAN KEY

"For me, wood is alive"
Pascal's work is always characterized by a birth, and equilibrium, a purity and sensuality.

Mahogany with patinas
Steel base
35 x 34 x 10"

ANTONIO ARELLANES

LUZ NO. 2

"Antonio is a visionary engaged in creating works that help us grasp the newer concepts concerning space, time and light."

... Dr. Leonard Schlain,
 author *Art and Physics*

Mixed media on canvas
48 x 48"

JOAN BOHN

LESS THAN MAYBE

... There is an inherent need to document by preserving things we hold dear, leaving our mark, our memories that become little pieces with great presence.

Mixed media on wood
66 x 50"

SUZANNE DONAZETTI

VIOLET SERIES #8

"I like working with copper because it gives me a sense of the immensity of geologic time and keeps me in touch with the rhythms of the earth."

Ink and acrylic
on gilded copper
24 x 40"

HAL FIELDING

PLAY OF THE WIND

"I believe people like creating and enjoying art because it is an attempt to understand the true nature of what things really are."

Oil on canvas
30 x 40"

HAROLD E. LARSEN

HEAT OF PASSION

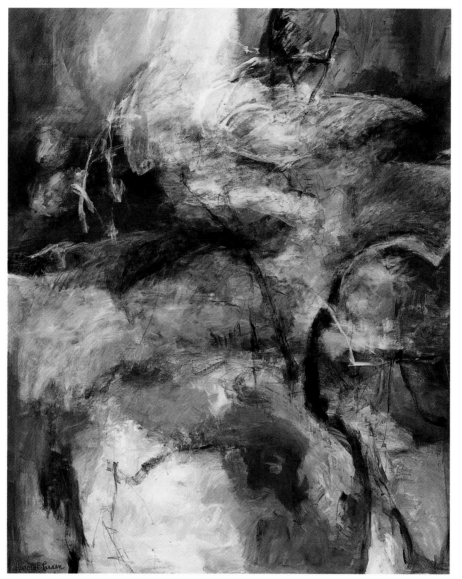

Acrylic on canvas
84 x 68"

Harold Larsen's radiant paintings have always had a strongly abstract element. Combining romantic precision with musical form and interval, these large canvases have spoken in their own language to those who would hear. Through the years, Larsen's figurative and landscape inferences have slowly subsided beneath his nonobjective art until all that remains is thought, color, and emotion. Within this vast internal territory is room for endless graphic reflection on change, reverence, joy, heartache, dreams, and discovery.

The artist, who has always signed his work with his formal name, is widely known in art circles and especially in New Mexico as Hal Larsen. It is here, in this land of strong light and startling clarity, that his art has progressed over twenty years to its present eminence. His work has been exhibited nationwide. Museums, embassies, and corporations have acquired his work, as have countless private collectors.

JAMES HAVARD

HOUSE AND GARDEN, 1999

Oil and wax on wood
20 x 22"

In his essay on James Havard, Ed McCormack observed that Havard's compositions center on single figures, and he often presents them in ornate gold frames that hark back to classical portraiture. While these frames serve to dress up and dignify his humble beings (and indeed almost to plead for their rightful place in art history), they also emphasize what a radical departure from standard portrait subjects these raw, strident presences, slashed and scratched into thickly impastoed surfaces, truly are.

In his prototypal outsider manifesto *Asphyxiating Culture*, the late Jean Dubuffet made a passionate case for what he called "raw art" – art that springs directly from the need for self expression rather than from a desire to imitate historical models. Where his argument falters, however, is in championing almost exclusively the work of primitives, mental patients, and other un-schooled isolates over that of sophisticated artists who channel their creative powers deliberately with the refreshing kind of directness exemplified in the recent paintings of James Havard.

Shaman-like, James Havard holds up a magic mirror in which we recognize, however reluctantly, our own naked souls.

KEN PRICE

SLOPE

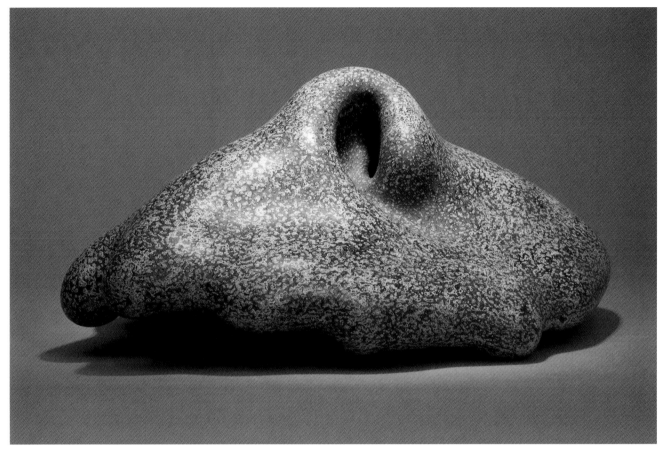

Fired and painted clay, 1999
9.75 x 22 x 16.75"

Ken Price, an artist based in Los Angeles and Taos, is well known for his small glazed or painted ceramic sculptures that he has been perfecting for over 40 years. His latest work represents a departure from his past architectural and egg-shaped works. These new pieces are loaded with anthropomorphic mystery and humor, treading a fine line between the two, always in perfect balance. Molded by hand and slowly fired, each piece is then painted with numerous layers of acrylic. A painstaking process of sanding through the layers of paint creates a stunning surface of thousands of tiny pore-like dots.

Upon first viewing this piece, titled *Slope*, one sees an eccentric ectoplasmic creature, perhaps pausing after moving across the pedestal. From a distance it appears to be a nearly monochromatic yellow with a frosting of green. Up close, the eye can get lost in the minute details of the dots, which are concentric rings of layered color. As with all the other works from this series, *Slope* has one mysterious, cave-like opening, inviting further exploration inside the piece with the eye or wary finger. In fact, Price invites viewers to prod, probe and run their hands over his ceramic forms.

Ken Price was called "the Fabergé of Funk" by art critic Robert Hughes in a *Time Magazine* article, yet he has always been a "by whatever means necessary" revolutionary in the world of ceramics. Among the first to rebel against the demure esthetics of American ceramics, to this day he is still far ahead, leading the pack.

PRISCILLA ROBINSON

MAGMA

Acrylic, abaca & cotton/fiberglass
18 x 37 x 5"

Priscilla Robinson pushes the experience of color, surface and texture, whether she is creating work for display in a large public environment or for the intimate setting of a personal collection. Born in 1948 in Washington, D.C., Robinson combines organic plant cellulose with space-age synthetics to create durable wall pieces and three-dimensional wall sculpture which is recognized internationally as innovations in her specialized field. Her work has been selected for display at the 1998 Holland Paper Biennale and at the 1996 International Triennale in Charmey, Switzerland.

Priscilla Robinson's work, with its magical dichotomy of materials, creates a dialogue between the infinite variety of nature and its simplified essence. "Paper is an abstracted skin of the earth," she says. "It allows me to explore the rises and falls of mountains and valleys, water and waves, and serves to remind us of our collective need to work with nature, not against it." The artist makes these observations from her urban studio in Austin, Texas, and the quiet grandeur of her country studio in her beloved Taos, New Mexico.

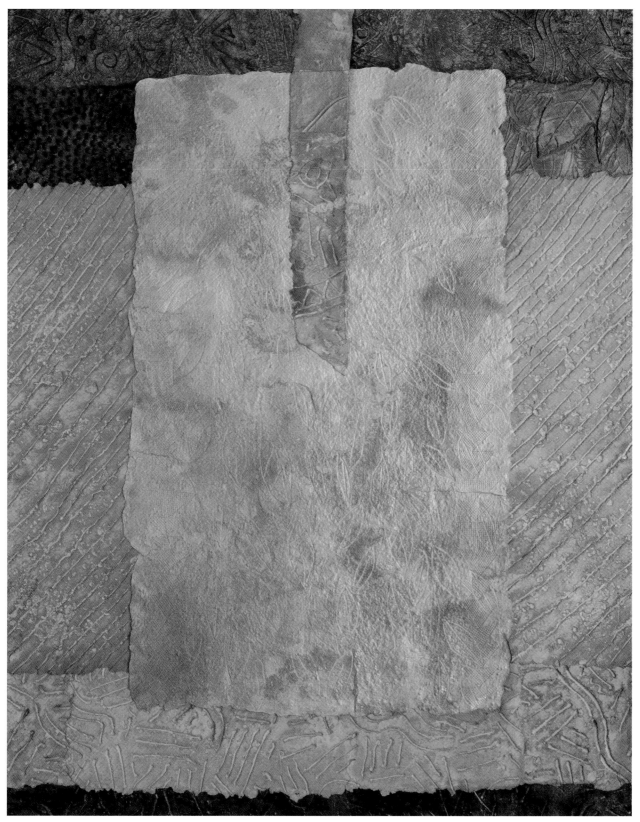

Acrylic, abaca & cotton/canvas
60 x 48"

EARL STROH

HEPHAESTUS

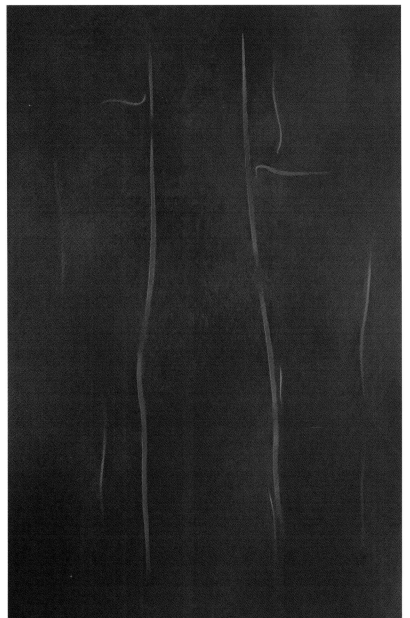

Oil on canvas
72 x 48"

Earl Stroh enjoys a reputation as one of the most distinguished longtime New Mexico artists, yet his work remains on the cutting edge by virtue of its sheer excellence. His education included the Art Institute of Buffalo, the Art Students League, and the University of New Mexico. He moved to Taos in 1948, where he was privately tutored by earlier legends Andrew Dasburg and Tom Benrimo. Through grants from the Wurlitzer Foundation in Taos, he studied intaglio in Paris, completing a large body of etchings at Atelier Friedlander as well as paintings on his own.

Earl Stroh has had one-man shows at galleries and museums nationwide, and is represented in the permanent collections of the Metropolitan Museum of Fine Art, the Art Institute of Chicago, the Cincinnati Art Museum, the Minneapolis Art Institute, the Denver Art Museum, the New Mexico Museum of Fine Arts, the Harwood Museum in Taos, the Dallas Art Museum, and many others.

ALYCE FRANK

SYMPHONY OF SUMMER

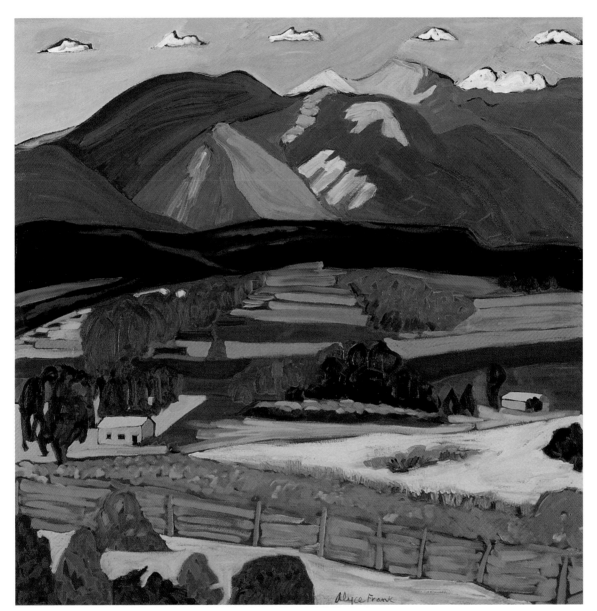

Oil on linen
36 x 36"

lyce Frank creates spacious compositions that let the color and energy of the New Mexico landscape shine through. A Taos resident since 1961, Frank studied with Robert Ellis, Rod Goebel and Richard Diebenkorn. She calls herself a Taos Expressionist. Her work has grown out of the Fauves, the German Expressionists and some of the classic Taos artists like Victor Higgins. Her works are included in many public and private collections. In 1999, New Mexico Magazine published *The Magical Realism of Alyce Frank*, a full-length book about her work.

"My interest is in the power of the scene... to create through color, a joyous statement about the place where I live," she says. "Art should have 'time' in it, which means that you have to break out of what you look at every day and get into something that's universal or eternal. That's why I love the landscape. It's always going to be there."

DINA PODOLSKY

FLOWERS FROM THE PAST

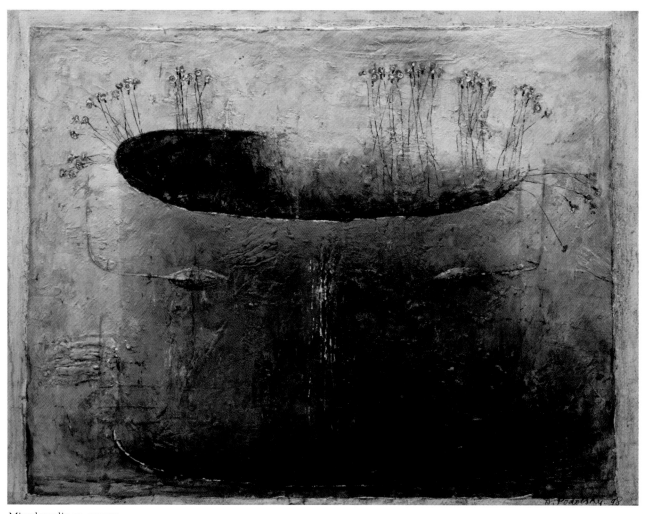

Mixed media on canvas
36 x 48"

Dina Podolsky was born in the former Soviet Union in 1953. First trained at the Polygraphic Institute in Moscow, she continued her studies at the Bezalel Academy of Jerusalem and the Avni Institute of Fine Arts of Tel Aviv.

It is essential to understand Podolsky's complex Slavic background in order to get the full impact of her work. Her pictorial language is extremely personal, almost autobiographical, a fictional and poetic identification with the closeness of past events. With her memory as a tool, Podolsky enfolds and changes her images, letting forms emerge by using surface ambiguities to suggest evolving memory. She gives special care to the effects produced by texture and patina. The passage of time is invoked by the use of collage, varnishes, and thick layers of mixed media. Her favorite subjects of the moment are large iron pots and large metal barrels weighted by dirt and eaten by fire, sun, and rust, in which she plants a handful of flowers. Podolsky has recently expanded her use of light, which creates effects of depth, shadow and clarity in warm and vibrant blues, reds, and earth tones.

The recent work of Dina Podolsky is a synthesis of a deep reflection connecting the past culture of the former Soviet Union with the living sensibilities of the ones who carry on its memories.

DENNIS DOWNEY

SANTA FE APRIL

Oil on canvas
70 x 80"

ennis Downey uses the word "cloudscapes" to differentiate his partially realistic, partially fantasy paintings from more traditional realism. He has become quite well known for these widely collected works. His range extends from intimate studies of the countryside and close-up impressions of wooded areas to the large, glorious canvases of brilliantly lit skies over peaceful landscapes that have become his instantly recognizable trademark.

Downey has lived and worked in Santa Fe for more than twenty-five years. He cites various regional influences including Wilson Hurley, who focuses on depth perception encompassing the vast Southwestern landscape, but he also admires the big skies and beautifully rendered cloud formations of national academician Eric Sloan.

Downey feels that his years of working with area artists have allowed him to become a better artist himself. "It could only have happened because of the diversity of artists who live here and who shared their experiences with me," he says.

STAR LIANA YORK

IN FULL BLOOM

Star Liana York's exquisitely rendered bronze sculptures respect the narrative tradition of the art of the American West. She successfully captures authentic aspects of the past and interprets historic figures with convincing realism. At the same time, she is part of a new group of artists who are reworking the stereotypical Western subjects, and her willingness to experiment with tradition and openly undertake new investigations sometimes compels her to step outside the genre that has brought her national acclaim.

Native American cultures – native women in particular – continue to be the source of inspiration for much of York's work. Their portrayal in her hands is spirited, articulate, lyrical, and animated by an individuality and personality that comes from the artist's exceptional ability to suggest internal states of mind with subtle expressions and gestures. But even though York has found the Western idiom to be versatile, powerful and right for many of her feelings and ideas, she is equally well-known for her Rock Art series, in which she creatively and dramatically interprets in three-dimensional work the Paleolithic paintings from cave walls in Europe. Additionally, an exhibition of equine images sculpted in her diverse styles, covering the horse from prehistory to the present and showing it as both aesthetic object and companion, is currently on tour.

Educated at the University of Maryland, the Baltimore Institute of Art and the Corcoran School of Art, York has received numerous awards and has been featured as the cover artist in many art magazines. Her work has been showcased in one-person exhibitions in galleries and museums around the country. In 1998, she was honored with a retrospective at the Gilcrease Museum in Tulsa, Oklahoma.

Allured by the frontier spirit that lingers beneath New Mexico's austere, high-desert landscape, York lives on a ranch in the heart of Georgia O'Keeffe Country, where she raises and trains quarter horses. She maintains a studio in Santa Fe.

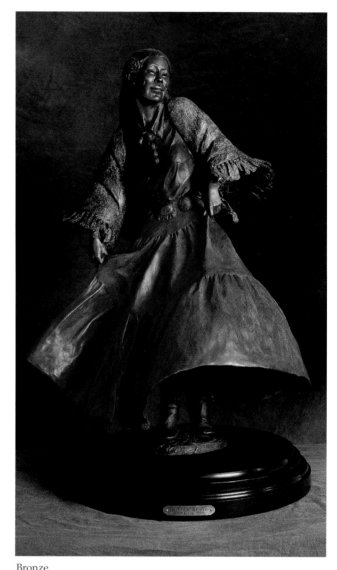

Bronze
30H x 24W x 24"D

VIRGIN SPRING

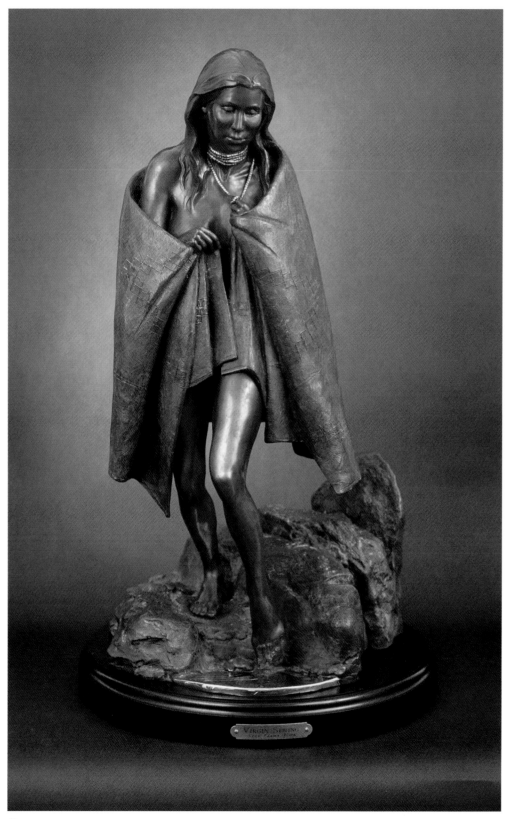

Bronze
29 x 15" and Life-size

PHYLLIS KAPP

WE'LL LOVE & LOVE & LOVE

Watercolor
35 x 42"

Phyllis Kapp moved to Santa Fe in 1983 and immediately fell in love with the landscape. Before her move to the Southwest she worked at the Evanston Art Center in Illinois with Paul Wiegard and chose as her subject matter the lyrical, romantic themes and extremely colorful palette typified by Marc Chagall, Wassily Kandinsky, and the Fauves of early twentieth century Paris.

Once in Santa Fe, she incorporated the lovely hills and skies into her vibrantly colored compositions. As she applied her exuberant style to her new surroundings, she developed the work for which she is known today. "Usually I don't paint an exact location," Kapp explains. "I'm more interested in communicating the feeling of the place, the land in motion, the play of shapes and colors."

Through the years as an active participant in the Santa Fe art world, she has seen her paintings go into corporate and private collections the world over as well as the White House, the Musée d'Art d'Ile de France in Paris, and the Museum of Fine Arts in Santa Fe. The happiness and vitality that radiates from Phyllis Kapp's art is a true reflection of her experience as an artist.

MAKE WAY FOR TOMORROW

Watercolor
52 x 44" framed

WILLIAM DeBILZAN

Mixed media 48 x 60"

WILLIAM DeBILZAN GALLERY, SANTA FE

NOT BESIDE MYSELF

William DeBilzan enjoys exceptional gallery representation in the United States, Europe and Japan. His mixed media paintings evoke a great sense of optimism and intrigue. A rich palette conveys the mind's eye of an artist who paints on a purely intuitive basis. Art enthusiasts have also become familiar with DeBilzan's work through its appearance in a variety of films and in several television series such as *Frasier*, *Spin City*, *Just Shoot Me* and *L.A. Doctors*.

RACHEL DARNELL

Oil and gold leaf on woven canvas 42 x 52" framed

LA REINA DE LA SALSA

Rachel Darnell achieves texture and variation by cutting her canvas into strips and weaving them, then applying rich layers of oil paint and metal leaf. Darnell studied in Israel, Egypt, and Greece, allowing her a peek into ancient cultures. "I developed the technique of woven canvas to emphasize the interconnectedness and interdependence of all things," she says. "The use of gold or silver leaf creates a jewel-like quality and evokes the tonal qualities of the ancients."

DOMINIQUE BOISJOLI

THE DAY WE MET

Acrylic/gold leaf
52 x 56"

Dominique Boisjoli draws her inspiration from the rich array of colors she observes at different times of day. In the mountains and lakes of New Mexico, she finds a harmonious balance between water and land, rock and sky. Her paintings of graceful, bright women combine a fluidity of movement with a keen sense of form. A former abstract artist from Canada, she found that her palette took on a warmth and opulence when she arrived in Santa Fe. Her love of the abstract merged with an appreciation of the land and an interest in the figure.

Dominique Boisjoli has been drawing all of her life and remembers being fascinated with color and perspective from a very young age. Her expressive painting style has always remained free and extremely vibrant. She uses only her hands and a palette knife to apply acrylic to paper in soft blends of color, highlighting her paintings with areas of pure gold leaf and creating subtle textures with varied thicknesses of paint and a heightened sensitivity to light.

Nineteenth Century Navajo Blankets

Transitional Chief's Blanket Variant

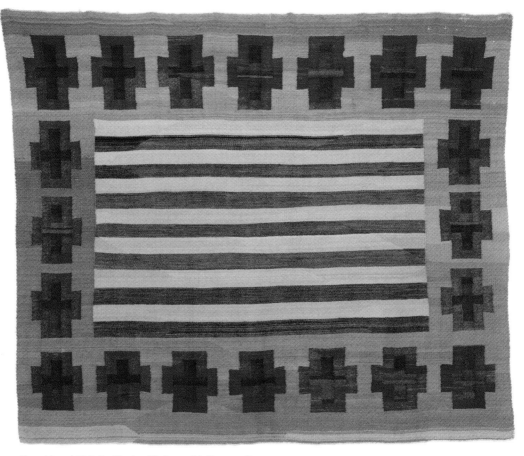

Transitional Chief's Blanket Variant with Twenty Crosses
Navajo, ca. 1885-1890
51 x 61"

The landscape of the Southwest is a landscape that looks into the earth, into the sky, and into the distance. Given that the Navajo were a nomadic people, it is neither an accident nor a coincidence that the best Navajo blankets were expressions of landscape and distance. For a Navajo weaver, each blanket was simultaneously a place to go and a place to be. To be in that place, and to go to that place, the blanket had to be created, moment by moment, yarn by yarn, until it was balanced and complete.

The Navajo blanket (above) strikes an emotional chord in people, probably because of the contrasts at work in its colors and designs. The combination of yellow and purple stripes is unique to this blanket. The border's energy comes from the placement of the twenty red and brown crosses on the camel-colored background.

The Moki serape (facing page) is a mosaic of color and nuance. It has a rhythm to its structure found only in the best classic serapes. The browns shift from dark to light; the blues are alternately deep and shallow; the reds create an irregular pattern that is almost pictorial, especially in the central panel.

CLASSIC MOKI SERAPE

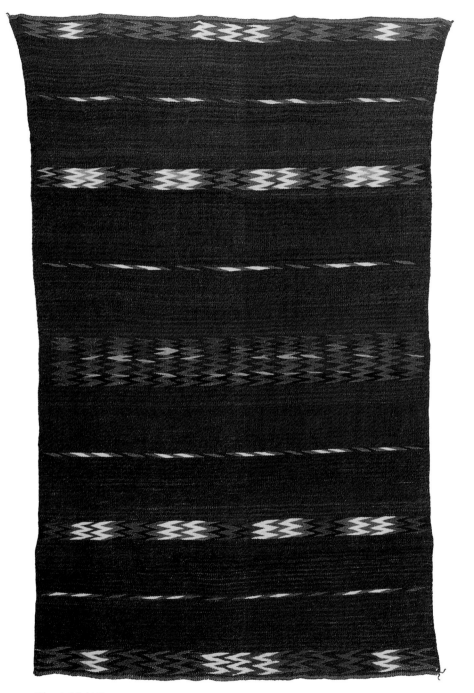

Classic Moki Serape
with four kinds of raveled Bayeta
Navajo, ca. 1860-1865
70 x 51"

PABLO ANTONIO MILAN

ALONG THE KALEIDOSCOPE FOREST

Acrylic on canvas
44 x 66"

Pablo Antonio Milan is nationally known for his contemporary art depicting Native Americans. The colors and images of his Southwestern heritage explode onto the canvas via portraits, warriors, dancers, and horsemen riding across the intense variations of the landscape. The artist is known for his distinctive use of color, his layered backwashes, and his loose but power-punched brush strokes.

Milan, who is a self-taught, has been a professional artist for fifteen years. He is a sixth generation New Mexican. His family, originally from Spain, first settled in Mexico. They moved to New Mexico, where they later founded the town of Milan in the Four Corners area. Pablo Antonio Milan was named Spanish Artist of the Year in Santa Fe in 1997. He was the featured artist of the 1995 Pink Floyd tour in San Antonio and at the 1997 Academy of Country Music Western Music Gala in Dallas. His art is in corporate and private collections throughout the United States and the world.

ESTELLA LORETTO

HOPE

Bronze
32H x 18W x 44"D

stella Loretto was born and raised in the Pueblo of Jemez, but she left at age sixteen to attend the Institute of American Indian Arts in Santa Fe. An American Field Service scholarship took her to Belgium as a Cultural Exchange Student and other programs allowed her to study in Oaxaca, Mexico, and then in India, Nepal, Japan, Tahiti, Fiji, New Zealand, Australia, Italy, and Washington State. She also apprenticed in her native pueblo. Back in Santa Fe, she studied monumental sculpture with Allan Houser, printmaking with Frank Howell, and jewelry design with Ray Tracey.

Although their influence is subtle, these experiences gave Estella Loretto an astonishing range. Every work of art she creates, in every medium, still embodies the gentle beauty of her origins. "I am committed to the passion of the creative expression. I am very moved by the challenge and dedicate my life to it. I would like to create pieces that speak for positive environmental change."

RENATE C. COLLINS

PURPLE ONIONS

Watercolor
26 x 30"

ONE - TWO - THREE PEARS

Watercolor
26 x 30"

C.S. TARPLEY

CELTIC KNOT

Blown glass with copper, silver and 24 karat gold
10 x 12"

C. S. Tarpley creates exquisite glass vessels in the shape of Indian pots, embellishing them with his own carefully developed vocabulary of design. He works with universal symbols that appear in European, African, and Native American traditions. What appears to be a Celtic knot, for instance, may be derived from Mayan temples. Certain Pre-Columbian Pueblo designs closely resemble Greek and Egyptian motifs. "Many of the motifs that are commonly referred to as Greco-Roman or Indo-European in our Western body of thought have, in fact, been independently developed by other cultures separated by vast oceans and thousands of years," Tarpley says. "The multicultural nature of these motifs appeals to my 'sense of place' in our modern culture, and allows me to honor the multiple nationalities and ethnicities that comprise my family."
In C. S. Tarpley's art, the meaning and significance varies according to cultural context. Each viewer may therefore experience it in a uniquely personal way.

MARIANNE HORNBUCKLE

Acrylic on canvas
26 x 44"

WINTER ROSE

WILLIAM E. PRESTON

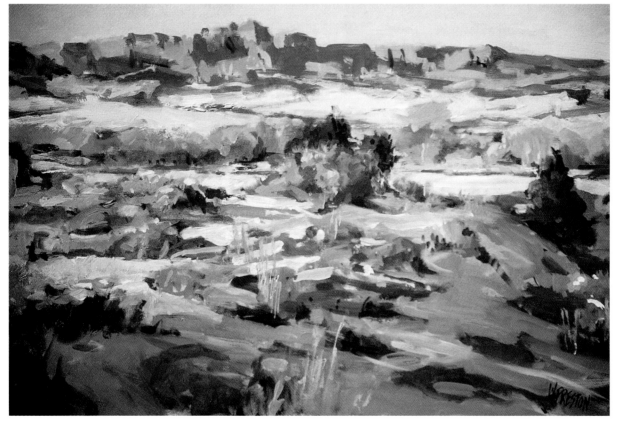

Oil on canvas
24 x 36"

LAS BARRANCAS

BRUCE CODY

PLAINS TOWN TEXACO

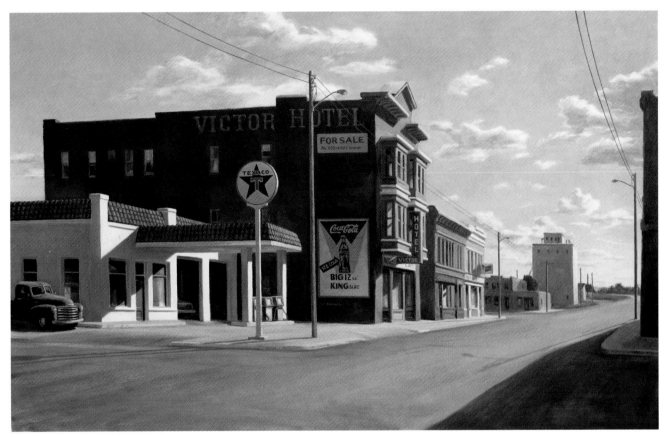

Oil
30 x 48"

Bruce Cody's oil paintings are about the lives we have lived as travelers and citizens of small towns in America. Each of us responds to the pristine morning light as it reveals the facades and signs of Cody's archetypal Main Street. His paintings, with their Hopperesque clarity of forms, light, and time of day, pull us past a Texaco sign and up to the gas pumps where we filled up our first car in preparation for the ritual cruise to our favorite drive-in café. The memories spring up fresh and unfaded.

Cody grew up in the American West, where his early informal training as an artist was in his father's sign shop. He worked along the rural roads of Wyoming, hand painting billboards and signs. Many

of the icons of his warmly portrayed images are those same logos and brand names. They are based on specific locations and experiences, but are filtered through memory and invention. While he later earned a graduate degree in art, did postgraduate work in London, and became a university professor, his thoughts remained with those first compelling images of his, and our, youth.

The credibility and strength of Bruce Cody's painting comes from a mastery of draftsmanship, precisely orchestrated color and a deeply felt appreciation of the space and light of the west. With these aesthetic tools and personal experiences, he conveys to us that his paintings are about our own biographies as participants in the American experience.

JOSEPH HENRY SHARP 1859-1953

HUNTING TALK

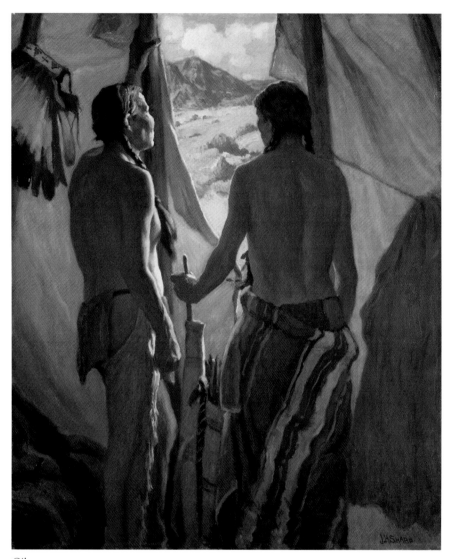

Oil on canvas
24 x 20"

Joseph Henry Sharp is considered the father of the Taos art colony. He first visited the tiny settlement near Taos Pueblo in 1893. Returning to the East Coast, he told other major artists about it, encouraged them to come, and continued to spend summers in New Mexico until he settled permanently in Taos in 1912. He was a founding member of the Taos Society of Artists. Sharp's primary subject was Native American life, from the nearby Pueblo communities to the Great Plains Indians. He believed that their traditional customs would be compromised by the advancing European civilization, and he hastened to record them in painting after radiant painting. Celebrated for his accuracy, he carefully noted the differing physiognomy, costume, and artifacts among various tribes.

Joseph Henry Sharp began his New Mexico career as an already recognized artist. His international importance was solidified by the body of work he produced here. He attracted prominent collectors such as Phoebe Hearst and Thomas Gilcrease during his lifetime. Today, much of his work hangs in leading museums.

CARL OSCAR BORG 1879-1947

NAVAJO CAMP

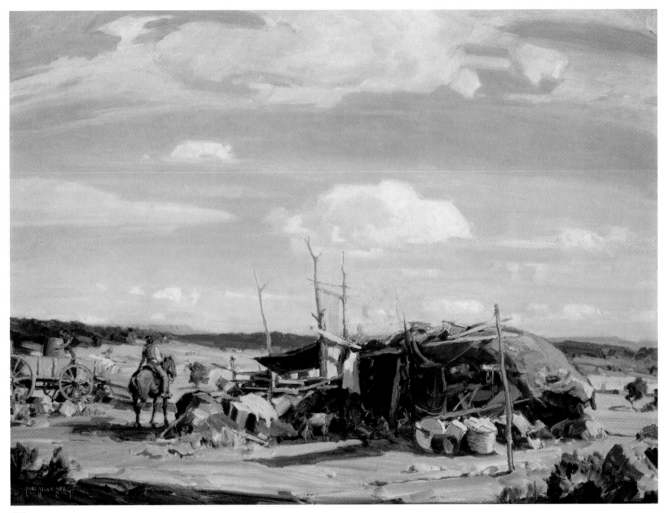

Oil on canvas
30 x 40"

Carl Oscar Borg, born in Sweden, was the eldest child of a rough career soldier and a gentle mother who endured poverty without complaint. In the course of a fairy tale life, the self-taught artist moved from impoverished beginnings in Europe to acclaim in the vast American West.

In 1901 Borg found his way illegally to Norfolk, Virginia. He painted for food and shelter around the East Coast, then signed on as a sailor on a ship bound for California, where his art brought him to important art patrons like Phoebe Hearst. His talent recognized, Borg traveled in Europe between 1909 and 1913 and had celebrated exhibitions in Rome, Venice, Amsterdam, Paris and London.

Carl Oscar Borg's paintings are included in the collections of the National Museum of American Art, Smithsonian Institution, C.M. Russell Museum, Museum of The University of California and Museum of Western Art in Denver, among many others. Olaf Wieghorst said of him, "Borg deserves a niche among the foremost painters of the American West. Like Catlin, Bodmer, Bierstadt, Remington and Russell, he has left a vivid record of Western history for future generations to enjoy."

VLADAN STIHA 1908-1992

NAVAJO RIDERS IN THE SNOW

Oil on canvas
24 x 32"

Vladan Stiha has become so closely identified with Santa Fe and the Western states that many do not realize he was past sixty when he arrived. Born in Yugoslavia and educated in the great art schools of Belgrade, Vienna, and Rome, Stiha left Yugoslavia after World War II and moved with his wife, Elena, to South America. There, he flourished, nurtured by the cultural emphasis on art and the freedom to develop the range for which he was to become famous. Already proficient in painting and sculpture, he experimented with other mediums, such as tapestries, frescos, and murals, and established the solid discipline that informed every work of art he created.

The couple immigrated to the United States in 1968 and settled permanently in Santa Fe in 1969.

Stiha found that the sunlit beauty of New Mexico suited his temperament exactly, for here he found the perfect combination of environmental beauty and artistic expression. Vladan Stiha believed that talent alone was nothing, and that art must come from the soul.

Stiha portrayed the Indians in his own inimitable style. His great ability as a colorist earned him places of honor in prestigious collections all over the world, including permanent collections in museums such as the Smithsonian, the Museum of New Mexico in Santa Fe, the Navajo Ceremonial Museum, the Museum of the Southwest in Midland, Texas, the Pioneer Museum in Colorado Springs, Colorado, the Oklahoma Museum of Art in Red Ridges, Oklahoma, and the Fort Huachuca Historic Museum in Arizona.

CHARLES AZBELL

THE LAND OF ENCHANTMENT

Acrylic on canvas
40 x 60"

HISTORIC PUEBLO POTTERY

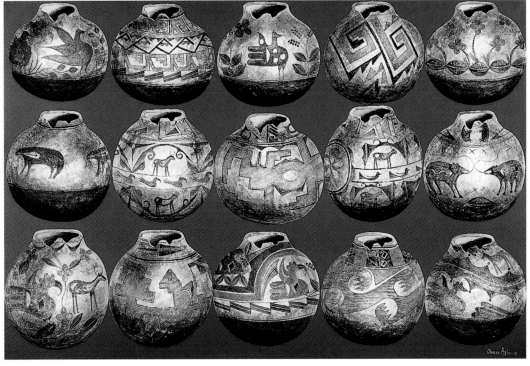

Acrylic on canvas
48 x 72"

DUANE MAKTIMA

SHELLFORM JEWELRY DESIGN

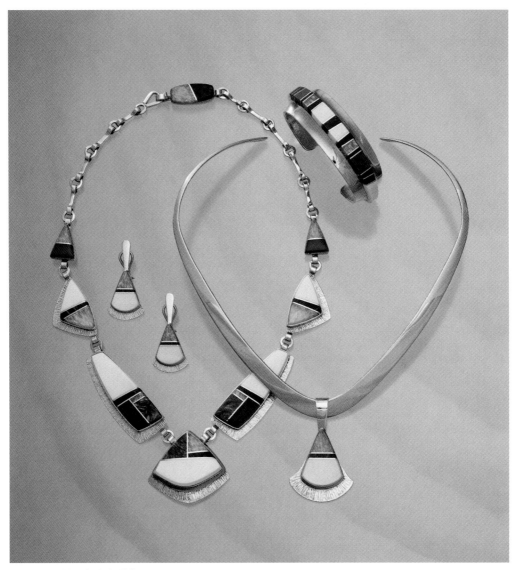

18 karat gold, inlaid shell forms
with pristine, chrysoprase,
sugilite, charoite and opals

uane Maktima is a contemporary jewelry designer of Laguna Pueblo and Hopi descent. According to his grandfather, the name "Maktima" means "searching for eagles." After twenty-five successful years and many awards, Maktima has become a mentor of many students. Northern Arizona University named him a Distinguished Centennial Alumnus in 1998. He founded the Pueblo V Design Institute to provide professional and technical assistance, workshops, and advanced training to Southwest Pueblo artists and craftspeople. The Institute is a source of values and imagery that enhances individual creativity. It strives to merge the new with the old, tradition with ingenuity, and to honor the unique Native experience as designers, artists, craftsmen, and craftswomen.

Maktima himself uses color and form to reiterate symbols of the ancient Southwest peoples, creating clean, simple designs that are composed of vividly colored geometric patterns inlaid into gold and silver.

HELEN HARDIN 1943-1984

CHANGING WOMAN

Helen Hardin's self portrait, *Changing Woman*, represents her joy at coming to terms with a life of hardship. It is perhaps this Santa Clara Indian artist's most significant personal image. An important innovator with roots in the Pueblo tradition, Hardin's use of controlled geometric lines and earth colors created a new vision of beauty to celebrate the culture of her Mimbres and Anasazi ancestors. Before her untimely death due to cancer, she had matured to master level as a painter and printmaker. By 1984, Hardin's masterworks had garnered her an international reputation which continues to grow in the new millennium.

Four-color etching, 1981
24 x 18"

SILVER SUN, HELEN HARDIN ESTATE, SANTA FE

GREGORY LOMAYESVA

Gregory Lomayesva's roots are in the Indian and Spanish Southwest, yet philosophically he is the keeper of the flame for the pop legends, with undertones of Basquiat and Rauschenberg and his very own postmodern vision. Everything from every source is grist for his meditations in sculpture, paint, and music. In turn, his work travels outward to Tokyo, New York, and other world capitals. Lomayesva is the face of the future.

Wooden Effigy and Mask

MARCO A. OVIEDO

BRISA DE PRIMAVERA BLUE CORN

Left: Bronze
5.5L x 5.5W x 13"H

Right: Bronze
5.5L x 5.5W x 13"H

Marco A. Oviedo is a recognized woodcarver and sculptor who lives and works in the historic Chimayo Valley north of Santa Fe. As an eighth generation descendant of a family of woodworkers and woodcarvers who originated in Oviedo, the capital of the province of Asturias in Spain, he learned his wood-carving skills starting at the age of five under the careful eye of his grandfather, Aurelio Maria Oviedo. The artist's own children continue the tradition and, like their father, have work in museums and private collections.

Oviedo goes beyond tradition by creating *santos* in bronze as well as wood, and has set up a foundry to cast his sculptures using the lost wax process. Inspired by prehistoric American petroglyphs and other rock art, he interprets two-dimensional images into three-dimensional bronze sculpture. He bases his original abstract compositions on Southwestern traditions.

Marco A. Oviedo has received awards for his pieces exhibited at Spanish Market in Santa Fe, and has been featured in articles in *Sunset Magazine*, *Bon Appetit*, *National Geographic* and other periodicals. Chapters on his life and work have appeared in books on New Mexico folk art.

Ramón José López

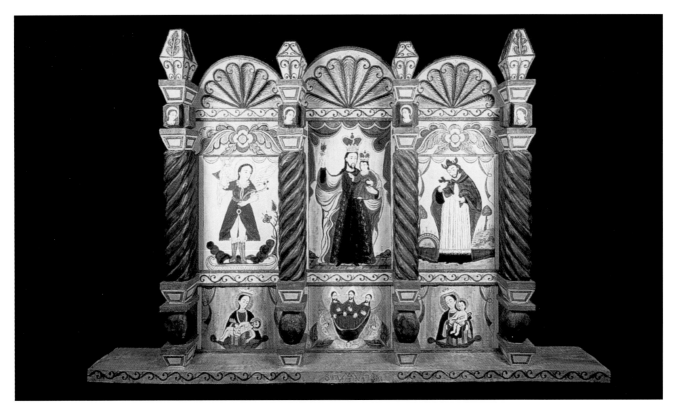

Altar screen
Pine hand-painted
8H x 9W x 1'D

Bo López

Hand engraved sterling silver plate 12" D

Nuestra Señora de Guadalupe

Bo López, age sixteen, learned traditional hispanic arts from his parents, *santero* Ramón José and jeweler Nance López, becoming versed in metal smithing, woodworking, and traditional painting techniques. He twice won the Youth Craftsmanship Award at Santa Fe's Spanish Market, and received several Spanish Colonial Arts Society Purchase Awards. He creates elaborate designs with traditional gravers on handmade silver patens, cups, knives, reliquaries and pendants. His art is included in the Maxwell Museum of anthropology, the Museum of International Folk Art, and other public and private collections.

ROGER MONTOYA

EVENING PEDERNAL

Roger Montoya is a lifelong painter. After college and several years as a professional dancer, he built an adobe studio in the foothills of the northern New Mexico mountains and began to create *plein air* paintings and mixed media pieces that capture the light and moods of nature and Montoya's own dynamic character. He is an annual exhibitor at Contemporary Spanish market in Santa Fe, and has shown his work in San Francisco and Hawaii. "My goal is to honor all living things in the cyclical chain of life," says Montoya, "while exhibiting a deference for this majestic planet we have been blessed with."

Oil
30 x 30"

ANDY BURNS

Oil on masonite
48 x 85"

ZEPHYR

ARMANDO LÓPEZ

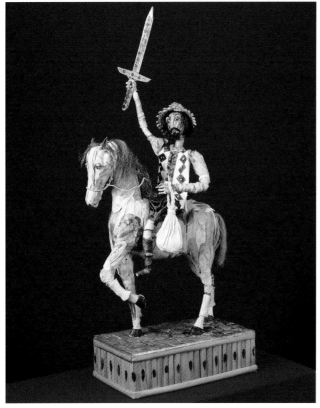

SEÑOR SANTIAGO

Armando López uses both pre-Columbian and Catholic imagery in his work. He learned his craft from his grandfather, who fashioned figures of corn husks and other natural materials in the Tarascan tradition of Michoacan, Mexico. An organic farmer as well as an artist, López weaves and binds river willow twigs, corn husks, reeds, cattails, onion skin, dried flowers, native grasses, and 24 karat gold leaf into *santos*, angels, altars, and other, more worldly figures. He also sculpts and fires the ceramic panels and ornaments used in his pieces.

Cornhusk, natural materials
30H x 10W x 9"D

RICARDO CHÁVEZ-MÉNDEZ

PLANETUS MUSICUS OPUS 7

Acrylic
36 x 48"

ROSIE SANDIFER

CATCH ME IF YOU CAN

Bronze
Ed. of 12 Sets - 12 Singles
4.5H x 4W x 6'D

Catch Me If You Can was chosen by the city of Champaign-Urbana as the theme for an art exhibition and as the motif for a Millennium Medallion. Sandifer was inspired by seeing a group of children on rollerblades. "As the bladers whizzed past me on the bike trail," she says, "their mobility and independence impressed me. I absorbed all that I could about the movement of their arms and legs and their billowing clothing, and then I created small memory sketches in clay. I tried to capture the freedom of moving quickly, unbound by time and space. Collectors arrange the different figures as they choose – massed together as I designed them, strung out ten feet apart, or racing forward abreast of each other."

NESTING

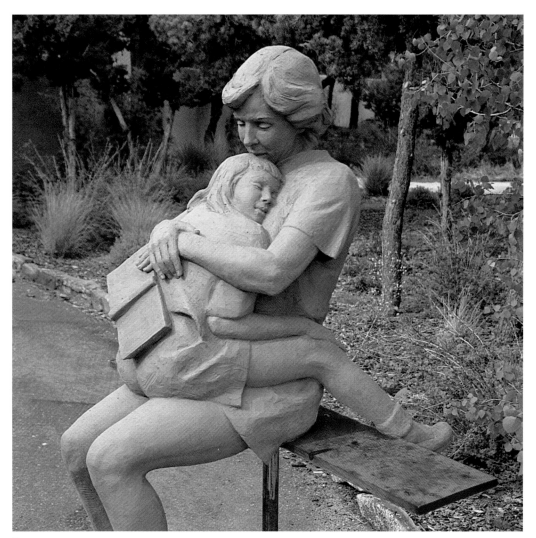

Bronze
Ed. of 24
4H x 4W x 5'D

osie Sandifer got a firsthand education in early twentieth century sculpture while wandering the elegant lawns of Brookgreen Gardens at Murrell's Inlet, South Carolina. As an adult, she has become a fellow member of both the National Sculpture Society and the American Artists Professional League. She participates in exhibitions and galleries internationally. Her work is included in the public collections of Brookgreen Gardens, Genessee Museum in New York, Museum of the Southwest and Texas Tech Museum, both in Texas, as well as other museums and universities, banks, corporations, and private collections.

Sandifer created this sculpture and began to consider what she would use for a title. "I observed a duck hen building her nest in my back yard," remembers the artist. "She laid her eggs and began hatching them, protecting them constantly. One morning I awoke to see twelve little ducklings wobbling along single file behind her. Soon after, they all left the nest and headed for the lake. I chose *Nesting* for a title because, in my sculpture, the child is still in the nest."

RICHARD ALAN NICHOLS

DEEP BLUE PASSAGES

Oil
22 x 28"

Richard Alan Nichols lives and works in the mountain village of Taos, which he "rediscovered" for himself when he moved there. "It was home from the first moment I saw it," he says. Taos, a century-old art colony, is fabled for its clear, cool light. Nichols' approach to painting the landscape is warm and sensitive. The result is a visual poem that perfectly captures the rugged beauty of a tumbling mountain stream. The delicate hues of rocks and foliage are enriched by the play of sunlight against the shadowy depths of the canyon.

Nichols is an internationally acclaimed artist whose paintings are in private and permanent collections throughout the world. Working in oil, charcoal, and watercolor, he creates works of art that have earned him many prestigious awards as well as inclusion in such top national juried exhibitions as Oil Painters of America and Arts for the Parks.

ROD HUBBLE

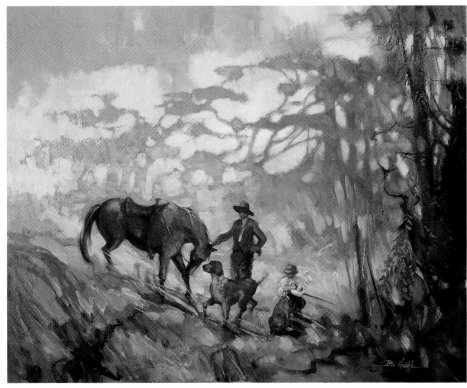

Oil
24 x 36"

ROD HUBBLE GALLERIES, SANTA FE

COMMUNION

Rod Hubble departed from his well known landscape work for this painting after he read *A Story Like The Wind* by Laurens Van Der Post. A certain passage about communion between "... dogs and horse, age and youth, experience and innocence ... the evening light of Africa wrapped about them like Indian silk ... " prompted him to make a small pencil sketch followed by intermittent work for eight months that produced this painting in honor of the writer.

BOB ROHM

Pastel
16 x 22"

HOT LIGHT

Bob Rohm is fascinated by the patterns created by color and light. He communicates their abstract essence through representational painting. Rohm is vigorously involved in the art world. His work is collected internationally and has been featured in national publications. He is a Signature Member of the Knickerbocker Artists, is listed in *Who's Who in Art, Architecture and Design*, and holds memberships in the Oil Painters of America and the Pastel Society of America.

DENNY HASKEW

WHITE DEER OF AUTUMN

Denny Haskew takes an intensely personal approach to his bronze and stone sculpture. His creative process begins and ends on an emotional note, and in between comes a blend of meditative attention to the subject and mindful observation of technique and composition. Haskew states that he tries "to enter with my eyes and my heart wide open to just see and feel the pulse of our world and what is beyond."

Always, he directs his thought toward his Native American heritage, even on the occasions when that is not his chosen theme. His Potawatomi ancestors were moved by the United States Government from the Ohio River Valley to Kansas. They relocated to Oklahoma, where they were allotted land in Potawatomi County. Haskew's dual Irish-Indian ancestry provides him with a poetic spirit and a sense of cultural history that informs each work of art.

Haskew maintains a studio in Loveland, Colorado, the site of several important bronze foundries. He is noted for his experimental work with stone patination. A member of the National Sculptors' Guild, he takes an active role in the art world. He participates annually in the historic Santa Fe Indian Market sponsored by the Southwestern Association for Indian Arts. He has completed a number of public installations and was named one of the four most collectable living Native American artists by *Southwest Art Magazine*. His work is in the permanent collections of the Smithsonion Institution in Washington, D.C., the Gilcrease Museum in Tulsa, Oklahoma, and the Wolf Creek Museum in Bastian, Virginia.

"As Denny Haskew has grown in stature and achievement," says J. Brooks Joyner, Director of the Gilcrease Museum, "he has become one of America's most prominent contemporary sculptors. The dramatic form, rich content and evocative spirit of his work has captivated lovers of art, collectors and museums for the past twelve years, and established him as a significant figure in the development of sculpture in the United States at the close of the 20th Century."

72H x 38W x 28"D
Ed. of 15

SUZANNE BETZ

BONNIE & CLYDE

Acrylic/graphite/mylar
21.5 x 17.5"

Suzanne Betz paints abstract and representational work, moving back and forth effortlessly between the two. In some instances, a ghostly horse or human being will hover within a bright non-objective work. At other times, a group of solid yet strangely translucent images of people and animals will glow against a deep, mysterious background.

A lifelong painter, Betz lived, worked, and exhibited her art in Hawaii for many years, gaining recognition and representation in public, private, and corporate collections. When she moved to Taos, she brought with her a sophisticated palette, a mature range, and a fresh eye for the colors and the spaces of that charmed countryside. She experienced a sense of freedom that she continues to translate into a never-ending series of luminous paintings.

DIMITRY SPIRIDON

AMERICAN GOLD

Bronze limited edition
28"H

D imitry "Domani" Spiridon endured agony as a political prisoner in his homeland of Salcia, Southern Romania, and has known the pain of life without horizons or expression. Freedom and the magnificence of the spirit in the transcendent forms of racing stallions, stalking pumas or careening eagles are motivating forces behind his inspired bronzed sculptures. In his choices of subject matter, creatures of grace and

majesty are reverently held in a moment of purity, evoking awe and admiration. For him, his work must be a celebration of life.

To view an unbridled spirit, one remembers that freedom often commands a price, one which Domani has experienced personally and chooses now to transform into an exhilarating collection.

RAY VINELLA

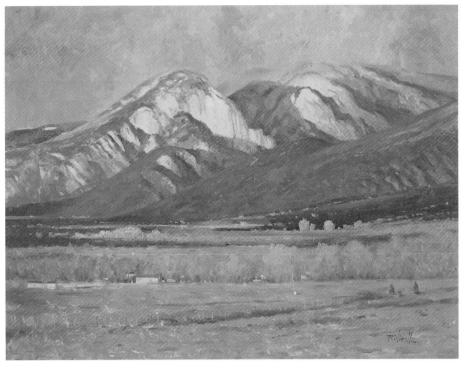

Oil
30 x 40"

BRAZOS FINE ART, TAOS

THE MOUNTAIN

Ray Vinella has been an integral part of the Taos art community for 30 years. His paintings and sculptures are closely identified with Taos. He has conducted countless art workshops, bringing Taos to the rest of the world. But this artist, like those who arrived a century ago, was raised and educated in New York. Like them, he exists simply to convey to others the heightened beauty and magic of northern New Mexico.

RORY WAGNER

Acrylic on canvas
48 x 46"

THE TEN

Rory Wagner has lived and worked in Taos for over twenty-five years. He is well known for his compelling portraits of Native Americans and other indigenous people. The figure in this piece is a friend from the Crow tribe, and the subject is taken from a favorite writer's work. Rory Wagner's paintings hang in private and corporate collections throughout the world.

CLASSIC NAVAJO SERAPE

ca. 1850s
72 x 50"

NORTHERN PLAINS BEADED WAR SHIRT

ca. 1870s

HOPI SHALAKO MANA KACHINA

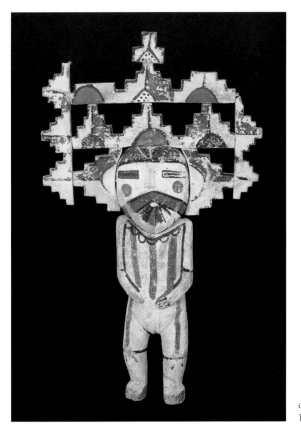

ca. 1880
17"H

SAN ILDEFONSO PUEBLO STORAGE JAR

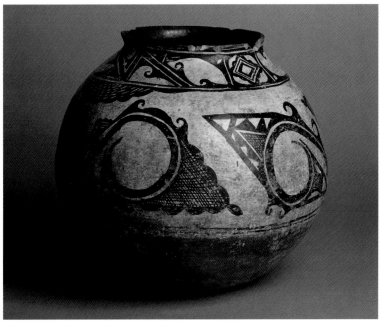

ca. 1800
16" D

DOUG SCOTT

SISTERS OF THE WIND

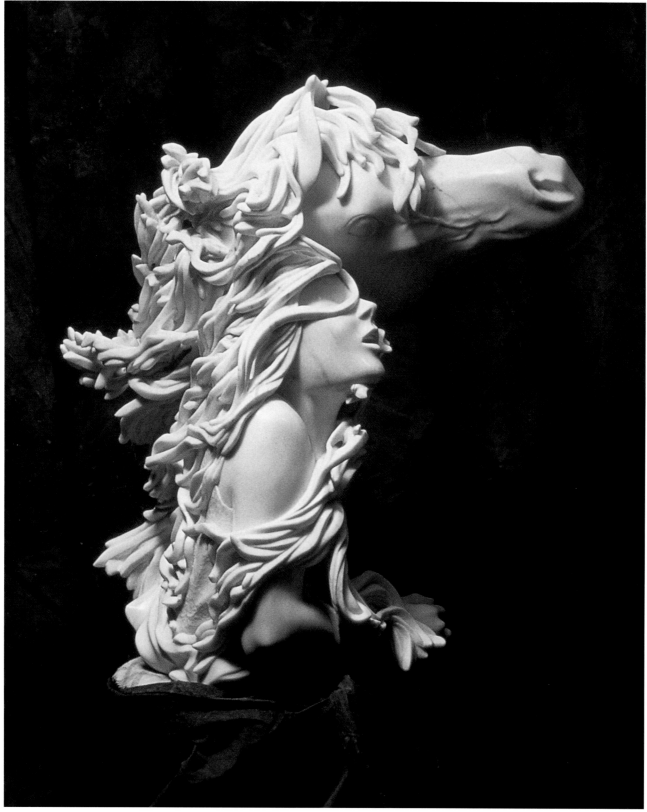

Marble
Life-size

CAROLE LAROCHE

EXODUS

Acrylic on canvas
80 x 70"

C arole LaRoche's art inhabits a calm, beautiful world where mystery and symbolism are the only realities, and none of the beings are quite tame. Exotic beasts crowd some canvases; masked or masklike faces watch intensely from others. Especially interesting are the works that combine human and animal figures, for their quiet interaction provides an endless resource for the imagination. Wolves conjure up the ancient bond between people and wild creatures. One figure may hold a fish and another will cradle a baby, posing a conundrum that is believed without being understood.

Carole LaRoche's success comes partly from her unique subjects, but is enhanced by her technical brilliance in a dazzling range of mediums, from large canvases and collages to pastel, acrylic on paper, monotype, serigraph, and iris/giclée prints. She settled on Canyon Road in Santa Fe two decades ago, and has attracted collectors from Europe, Asia, and the Americas.

NAGARAJA

TIBET 15TH CENTURY

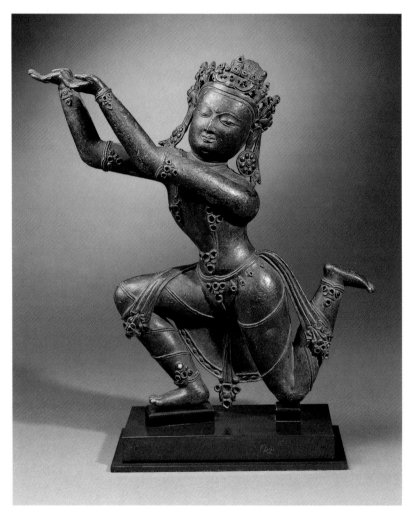

Densatil Monastery
Cast bronze
16"H

This figure of a kneeling, smiling young prince of the Nagas (serpent kings) has become a familiar icon of the ancient culture of Tibet. Originally the image formed part of the vast and glorious religious complex of Densatil in Central Tibet. An extraordinary temple complex whose construction was begun in the second half of the 12th century, this great monastery reached the height of its power and glory in the 14th and 15th centuries, when it was the seat of powerful Lamas who exerted great spiritual and temporal power. Kneeling *nagarajas* such as this one joined innumerable figures of guardian kings, Dakinis and dancing offering goddesses as decoration for the remarkable

stupas used to house the relics of the great Lha-btsun (god-kings) who were the spiritual and temporal chiefs of the Monastic city. This entire complex, which featured great *stupas* and temples made entirely from gilded copper, was completely destroyed during the cultural revolution during the 1960s and 1970s, which largely wiped out the entire cultural history of both Tibet and China.

These figures show a strong stylistic influence from Nepal, and there is some evidence from short inscriptions on pieces from Densatil that the various parts of the great metal *stupas* may have been manufactured in Nepal and sent for assembly to Tibet.

EGYPTIAN USHABTI
SERVANT IN THE AFTERLIFE

These symbolic servants in the afterlife (*Ushabti*) were placed in the tombs of ancient Egyptian nobility and persons of wealth or distinction during the elaborate burial ceremonies. The servant figures were believed to be endowed with magical powers that would allow them to assume the duty of performing any tasks that the deceased might be required to do in the afterlife. Most *Ushabti* were inscribed with powerful spells to protect the deceased. It was customary to bury three hundred and sixty-five *Ushabti* with the deceased, one for each day of the year. *Ushabti* were made from a variety of materials including wood, stone, and a quartz based ceramic material known as faience.

26th Dynasty, 664-525 BC
182mm

APULIAN RED FIGURE LEKANIS

Footed dish with handles and lid
Winged Eros Seated on a Rock
4th Century BC
135mmD x 105mmH

PAINTED BUDDHIST WALL FRESCO

YUAN/MING DYNASTY CHINA

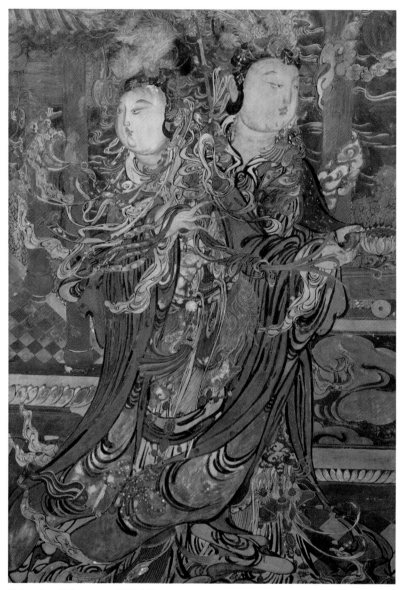

Painted wall fresco, ca. 1300 AD
60 x 42"

his painting of two robust *Bodhisattvas* shows them attired in beaded jewelry and phoenix headdresses. Their scarves and their elaborately layered robes dance and swirl in the wind, a clear reference to the spiritual intensity that evokes *chi*, or inner life. One holds a lotus pod. The *Bodhisattvas* stand in front of a pavilion with columns in deep red and a rolled shade of bamboo. The sun can be seen through the scudding clouds in the upper left-hand corner. The style is highly animated and immediate which augments the forceful brushwork and evokes a sense of the painting being in harmony with the creative forces of nature. The *Bodhisattvas* are venerated as loving guides and protectors of the human race in the present age. The heavenly and mystical qualities of the painting are the result of the sacred nature of such a painting and, as such, it would have adorned the wall of a Buddhist monastery.

KO-DANSU

MEIJI-ERA (1868-1912)

26H x 24W x 13"D

This Meiji-era *ko-dansu* is a particularly fine example of the small personal chests commonly brought to the husband's household by the new bride. These chests held some of the Japanese woman's most prized possessions, and family crests were often seen incised on the iron hardware of the *bo* or locking bar. This example, depicting a single cherry blossom and other floral imagery, dates from the 1880s and is from the town of Tsuruoka on the Shonai plain in northern Yamagata Prefecture. The carcase is finished with wiped lacquer over Sugi (Japanese cedar) and has drawer fronts and doors of Keyaki (Zelkova) finished with *kijiro* lacquer. The iron handles are in the *warabite* style.

NICHOLAS MUKOMBERANWA

MY SPIRIT AND I

"I think it's some kind of remedy for me to survive … I'm talking about sculpture. Without it, there is no life … I find it's like communicating with the unknown, and exposing it to us here."
 – Nicholas Mukomberanwa
 British documentary: *Talking Stones*, Granada Productions

"Nicholas … one of Zimbabwe's most gifted and successful sculptors, is highly regarded internationally. His work is in the permanent collections of many international museums."
[Museum of Modern Art, New York; Field Museum, Chicago; Museum of Mankind, British Museum, London; and others. Also exhibited at Musée Rodin, Paris, and Yorkshire Sculpture Park, U.K.]
 – Exhibition Catalog, *The Stone Sculpture of Zimbabwe*, 1997
 Kirstenbosch, Cape Town, South Africa

Serpentine/Twilight
28 x 10 x 7"

HENRY MUNYARADZI 1931-1998

THE FAMILY

"Henry, the best known Shona Sculptor, is like a magician who knows how to translate the essence of any being or spirit into stone. With tenderness he selects the stone which he feels contains the spirit of an animal, a man, or even the wind. He then works to free the spirit, immortalizing it with an hypnotic gaze that contains an almost moral naiveté."
 – Oliver Sultan
 Life in Stone, 1992

Fruit Serpentine/First Light
Left: front view; Right: rear view
15 x 13 x 4"

BRIGHTON SANGO 1958-1995

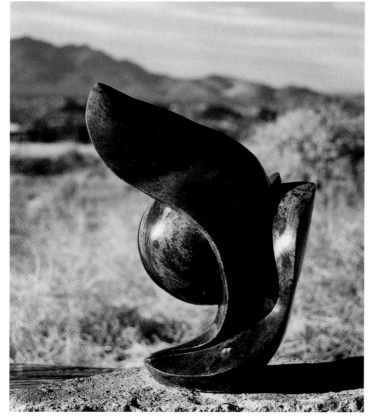

PROMISES

"Sango's work uses the power of pure abstraction to convey profound emotion. Possibly, without knowing it, he has established a new direction for Zimbabwean sculpture."
> – Celia Winter-Irving
> *Stone Sculpture in Zimbabwe*:
> *Context, Content, and Form*, 1991

"Sango's work challenges Western perception of what African art should be."
> – Roy Cook, Matombo Gallery, Harare, Zimbabwe

Serpentine/Winter Light
21 x 15 x 12"

AGNES NYANHONGO

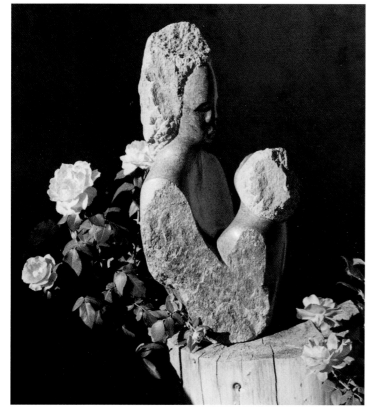

MOTHER AND DAUGHTER

"As Zimbabwe's leading woman artist, her work has taken its place ... on the international circuit."
> – Exhibition catalog, *Sculpture in the Park*, 1993
> Loveland, Colorado

"Agnes ... produces universal images with simplicity, quiet dignity, beauty, and finesse. She often expresses the role women play in society as they struggle with freedom."
> – Exhibition catalog,
> *Moderne Afrikanische Kunst*, 1994
> Palmengarten, Frankfurt, Germany

Golden Serpentine/Summer Light
22 x 9.5 x 10.5"

RAYMOND NORDWALL

ON THE CREATOR'S TRAIL

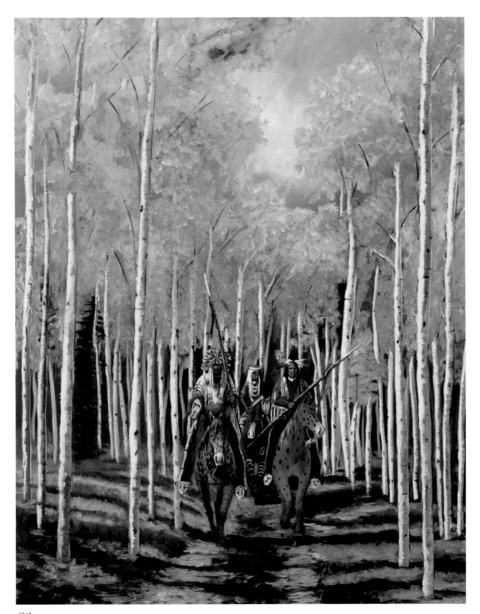

Oil
50 x 40"

Raymond Nordwall grew up in Oklahoma, where he lived and studied with artist Johnny Tiger, Jr., and was influenced by the "Kiowa Five" and Jerome Tiger. After studying traditional Indian painting with Dr. Richard West at Bacone College, he went on to Oklahoma State University, and then moved to Santa Fe to attend the prestigious Institute of American Indian Arts. At IAIA, Nordwall was strongly influenced by the works of contemporary Native American artists

T.C. Cannon and Earl Biss. After graduating from IAIA with honors, he studied with artists Frank Howell and Andrew Peters.

Nordwall's unique style draws upon his Pawnee/Ojibwe background, his knowledge of native culture, and his love of nature. Traveling around the country painting the landscape, he imagines the scenes that used to be.

VIC PAYNE

EAGLE CATCHER MONUMENT

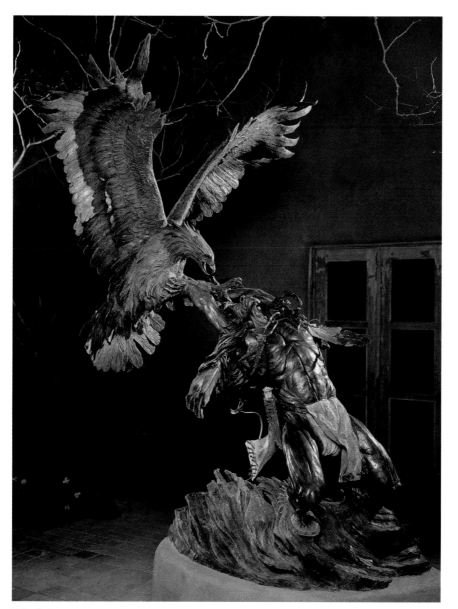

Ed. of 25
90H x 72W x 71"D

Vic Payne did a lot of hands-on research before he began sculpting cowboys and Indians in historical settings. As a boy, his top priorities were "roping critters, riding hard, and flying high. Then the sculpting bug bit," he says – and with it came a full time career as an artist. The Eagle Catcher is his gesture of respect for the Native American people and their traditions.

Payne is the son of well-known painter and sculptor Ken Payne. As a child, he was fascinated by the clay his father was molding. His father instructed him in the art of sculpting and carefully exposed him to the Old West through books, art shows and visits to museums where he was fascinated by the works of Charles Russell and Frederic Remington.

Vic Payne often creates his sculpture before an intent audience of visitors. "My work is more important to me now than ever," he says.

Navajo Red Mesa Textile

Eyedazzler Design

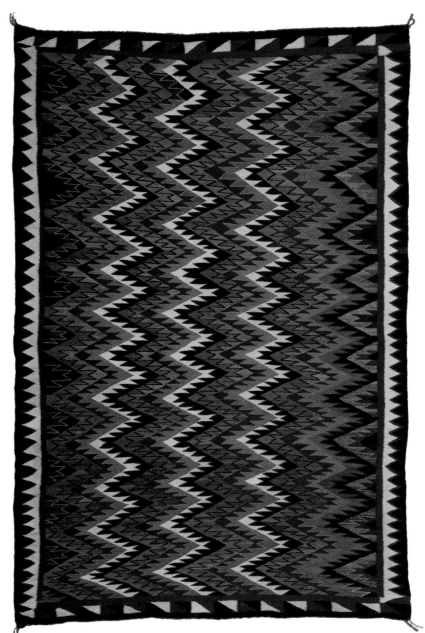

Textile, ca. 1915-1930
87 x 60"

This Red Mesa Navajo textile is an Eyedazzler design, aptly named for its intricate pattern infused with brilliant color. Red Mesa is within the rug weaving area of Teec Nos Pos (Circle of Cottonwoods), Arizona, near the Four Corners border with New Mexico. The weavers of Red Mesa use fine aniline dyed handspun wool yarns as well as colorful commercial Germantown yarns to weave outlined designs of concentric geometric elements, rows of serrated zigzags, and terraced borders. Most of the design elements within the Red Mesa style are bordered or outlined in a contrasting color. Navajo textiles from each weaving area are identified by certain stylistic patterns and colors. In general, the Red Mesa patterns of design influence are Oriental, dating back to the early 1900s when the Navajo traders were appealing to the decorating tastes of the East Coast market.

ALLAN HOUSER 1914-1994

YOUNG WOMAN

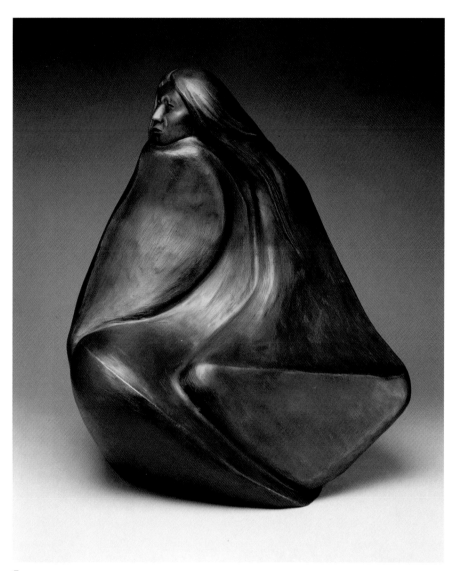

Bronze
25 x 21x 21"

Allan Houser is considered the most influential Native American artist and is credited with reviving the art of stone sculpture in the United States. He was the first child born to the Warm Springs Chiricahua Apache tribe after their release in 1914 from twenty-seven years of detention by the U.S. Government. Houser changed his name from Haozous at a young age, as was the custom of the time, but often signed his work with both names.

Houser taught at the Institute of American Indian Art in the 1960s and 1970s, moving away from the styles and media traditionally associated with Indian Art. His carefully developed sculpture esthetic was adopted by an entire generation of younger artists. He was accomplished in a variety of mediums, from delicate egg tempera to monumental sculptures of bronze, stone, and steel. Allan Houser's work is included in the Museum of Modern Art, the Metropolitan, the United Nations, the White House, and the British Royal Collection, among many others.

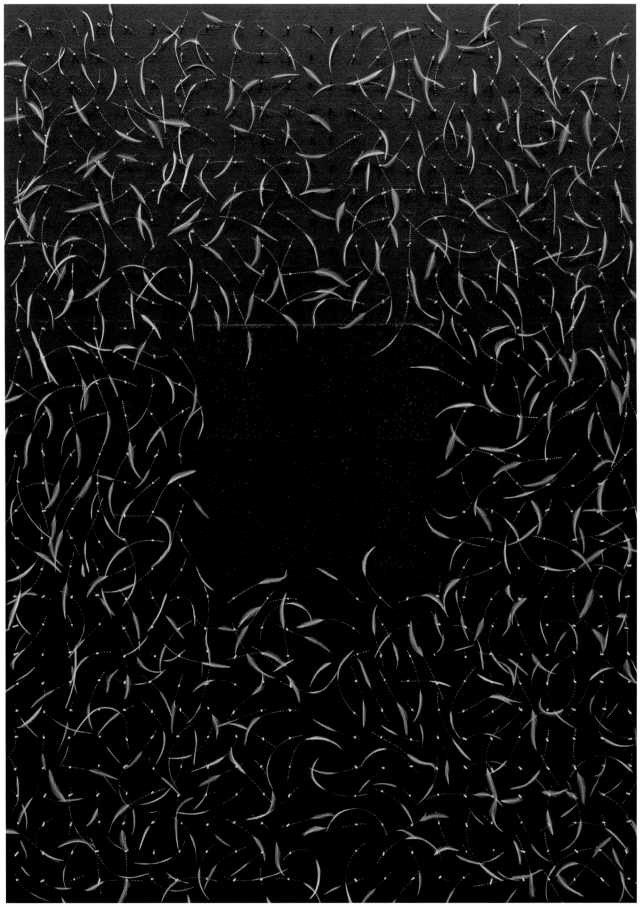

Judy Tuwaletstiwa
#19 Cadences
Mixed media on canvas
66 x 48"
Courtesy Linda Durham Contemporary Art

Gallery Index

UNSIGNED ART

PHOTO CREDITS